rethinking acrylic

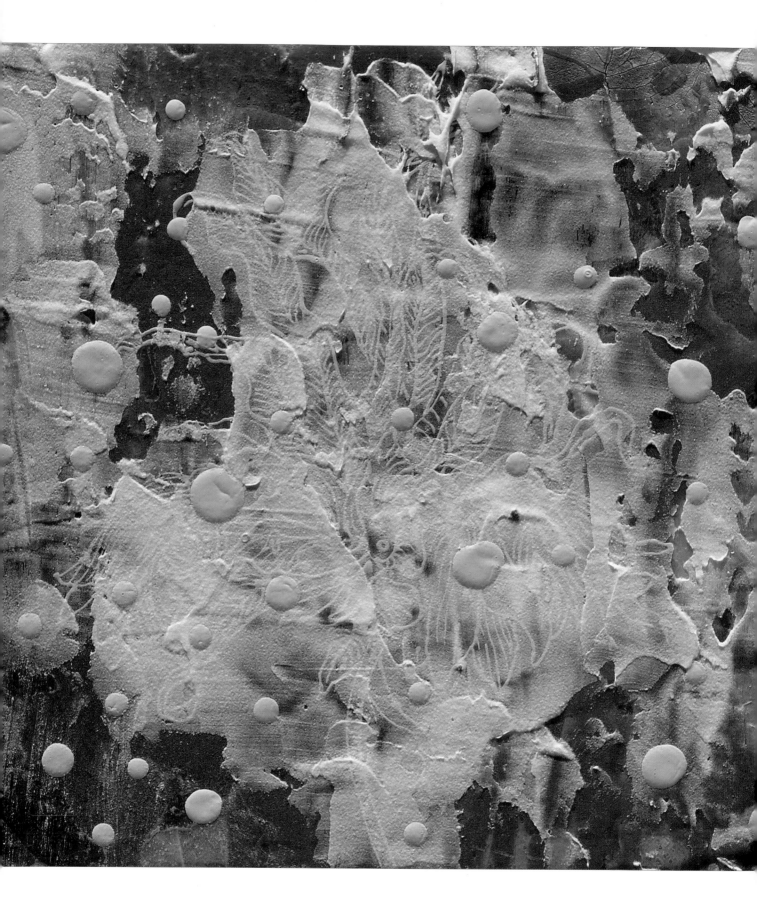

rethinking
acrylic
radical solutions for exploiting the world's most versatile medium

Patti Brady

NORTH LIGHT BOOKS
CINCINNATI, OHIO
www.artistsnetwork.com

about the author

Patti Brady received her BFA from the San Francisco Art Institute. Her paintings, prints and hand-painted books have been exhibited nationally at the Brand Library and Arts Center in Glendale, California; the Arch Gallery in Chicago, Illinois; Mills College in Oakland, California; and U.C. Berkeley in Berkeley, California. In 1994 her paintings were reviewed by the *New York Times*. She was awarded a Silver Award in the California Discovery Project in 1995 and was the recipient of the South Carolina Arts Commission Fellowship Award for 2006. Her work is in the collections of the Greenville County Museum in Greenville, South Carolina; County Bank in Greenville, South Carolina; and the Contemporary Carolina Collection in Charleston, South Carolina, among others. She is currently the Working Artist Program director for GOLDEN Artist Colors, Inc., and has lectured and taught on the use of GOLDEN Acrylics at a number of universities and art schools around the globe. Visit her Web site at www.pattibrady.com.

Rethinking Acrylic Copyright © 2008 by Patti Brady. Manufactured in China. All rights reserved. No part of this book may be reproduced in any form or by any electronic or mechanical means including information storage and retrieval systems without permission in writing from the publisher, except by a reviewer who may quote brief passages in a review. Published by North Light Books, an imprint of F+W Publications, Inc., 4700 East Galbraith Road, Cincinnati, Ohio, 45236. (800) 289-0963. First Edition.

fw
F+W PUBLICATIONS, INC.

Other fine North Light Books are available from your local bookstore, art supply store, online supplier or visit our web site at www.fwpublications.com.

14 13 12 11 10 8 7 6 5 4

DISTRIBUTED IN CANADA BY FRASER DIRECT
100 Armstrong Avenue
Georgetown, ON, Canada L7G 5S4
Tel: (905) 877-4411

DISTRIBUTED IN THE U.K. AND EUROPE BY DAVID & CHARLES
Brunel House, Newton Abbot, Devon, TQ12 4PU, England
Tel: (+44) 1626 323200, Fax: (+44) 1626 323319
Email: postmaster@davidandcharles.co.uk

DISTRIBUTED IN AUSTRALIA BY CAPRICORN LINK
P.O. Box 704, S. Windsor NSW, 2756 Australia
Tel: (02) 4577-3555

Library of Congress Cataloging-in-Publication Data

Brady, Patti.
 Rethinking acrylic : radical solutions for exploiting the world's most versatile medium / Patti Brady. -- 1st ed.
 p. cm.
 Includes bibliographical references and index.
 ISBN-13: 978-1-60061-013-4 (enclosed wire-o : alk. paper)
 1. Acrylic painting--Technique. I. Title.
 ND1535.B73 2008
 751.4'26--dc22
 2008025049

Edited by Kelly C. Messerly
Designed by Guy Kelly
Production coordinated by Matt Wagner

Photographs by Eli Warren appear on the following pages:
Cover, 14–19, 22–23, 26, 28–29, 31–33, 36, 38, 40–44, 46–47, 54–57, 59–60, 65–73, 76–81, 92–97, 100–103, 110, 112–114, 116–117, 124–125, 130–131, 136–138, 148–151
www.eliwarren.com

Photographs on pages 12–13 are courtesy of GOLDEN Artist Colors, Inc.
www.goldenpaints.com

Art from page 2
Fruitless Fruitlla
Patti Brady
Acrylic on wood panel
4" × 13" (10cm × 33cm)

Metric Conversion Chart

To convert	to	multiply by
Inches	Centimeters	2.54
Centimeters	Inches	0.4
Feet	Centimeters	30.5
Centimeters	Feet	0.03
Yards	Meters	0.9
Meters	Yards	1.1

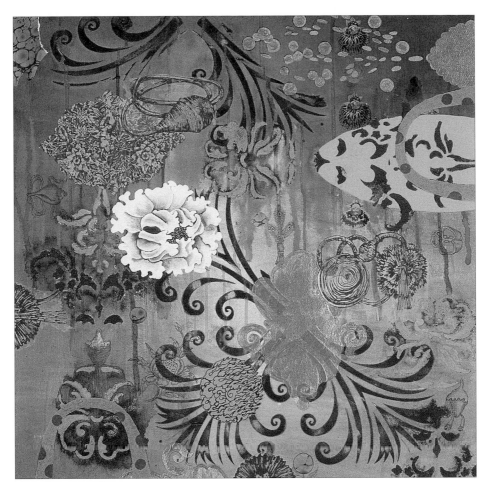

On a Silver Platter
Patti Brady
Acrylic and mixed media on paper
27" × 27" (69cm × 69cm)

acknowledgments

I must begin with thanks to Mark and Barbara Golden for creating the company Golden Artist Colors, Inc. and for their trust, friendship, and of course, for letting me hang out there for the last sixteen years. Much thanks and appreciation to my many friends there who have helped me, put up with me, supported me and shared much laughter: Ed Hettig (who believed I could do it, whatever "it" was), Jodi O'Dell, Sarah Sands, Jim Walsh, Bill Hartman, Dana Rice (endless editing and allowing me to whine), and especially Pat Pirrone, who supports me and all the fabulous artists that I work with in the Working Artist Program.

A heartfelt thanks to all the artists in this book, who shared their work, ideas and support. A special "xxoxx" to Jaq Chartier, who was my first collaborator, and to Barbara Jackson, Bonnie Cutts, Corrie Loomis-Dietz and Nancy Reyner, for hanging in there these many years, and Val, Roy, Tesia, Kevin, Judy, Adriana, Chris, Mark C., Sandie, Mary, and all the rest!

Many thanks and hugs for the support on the home front to Phil Garrett, husband, artist, musician—and big contributor to this book in many more ways than what appears on the pages.

And to the "kids" Aggie, Maddie and Rosie. And the behind-the-scenes support of Cyndi, Kimberlee and Emi—my family.

Thanks to the Fine Art Ramblers, for putting up with so many missed practices and gigs.

Thanks to Kate Spigner, my studio and office assistant. Without her, life would be a rocky road for sure.

Thanks to Eli Warren, who did the photography and was able to capture my vision.

Last but not least, thanks to Kelly Messerly, who understands deadlines and has nerves of steel. And to Jamie Markle for chasing me down.

dedication

To my father, James Ferrell Brady, who would have loved to see his daughter's name on the cover.

table of contents

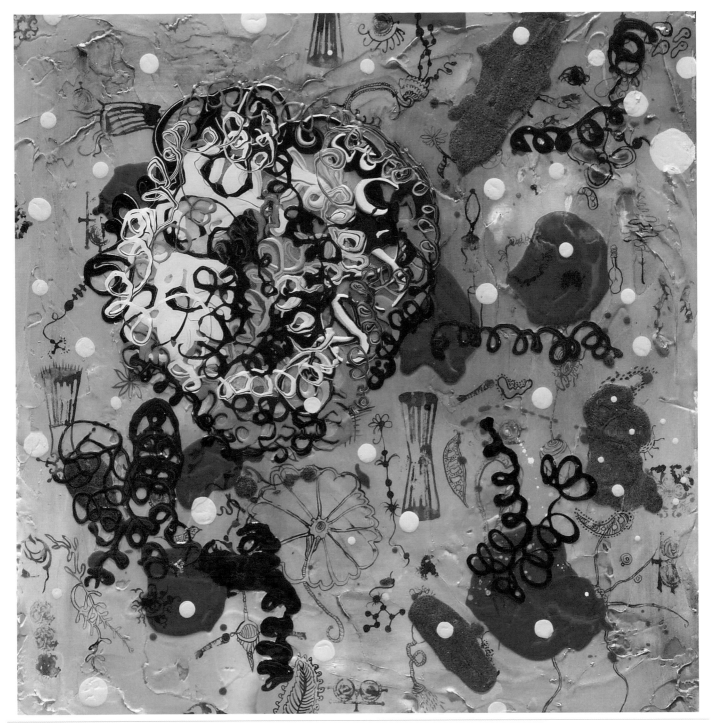

Loop de Loop
Patti Brady
Acrylic on wood panel
36" × 36" (91cm × 91cm)

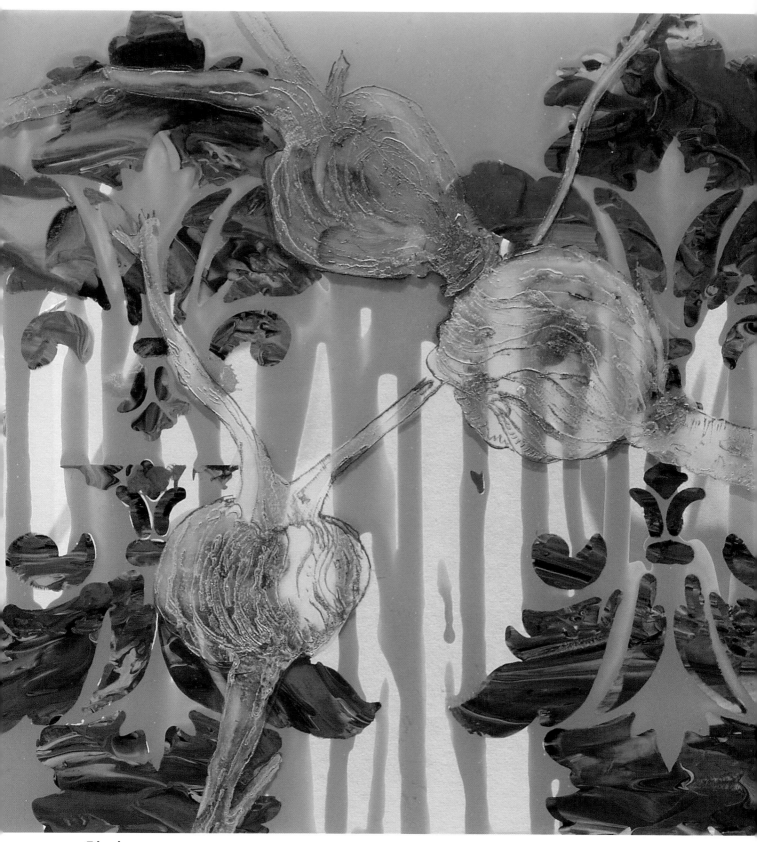

Tripod
Patti Brady
Acrylic on etched Plexiglas
12 " × 12 " (30cm × 30cm)

introduction

Have you ever walked into an art supply store, stood in front of the amazing array of acrylic products and just thrown up your hands in confusion, leaving the store without buying something new to experiment with? If you've ever wondered what to do with all those products, then this book is for you.

If you've been using acrylic in traditional painting forms, in this book you'll find grand, wild and inventive manipulations of acrylic that will get your creative juices flowing.

Compared to more traditional art mediums such as oil and watercolor, acrylic is still in its infancy. But what it lacks in years, it makes up for in its range of use. Acrylics appeared on the market for artists in the late 1940s as a quick-drying alternative to oil paint. In its early manifestations, it dried so quickly that more than a few brushes stuck immediately to the canvas!

Although acrylic has been around for more than fifty years, incredible advances continue to be made in the research and development of acrylic polymers and pigments. These advancements are attributable not only to the efforts of a few dedicated chemists, but also to the work of an entire community devoted to acrylic. There are a lot of brilliant minds taking these minute molecules very seriously.

an overview of acrylic

ACRYLIC POLYMERS CAN BE MANIPULATED

by artists in an amazing number of ways. There are simply

more mediums, gels and grounds—from pasty to pour-

able—available for acrylics than for any other painting

medium. This affords artists inexhaustible opportunities for

applying, pouring, brushing, scraping, squirting, swishing,

rolling, sanding and who knows what else. Acrylics are

compatible and mixable with a range of materials, allow-

ing for an explosion of mixed-media artworks, with infinitely

fewer rules than for other mediums.

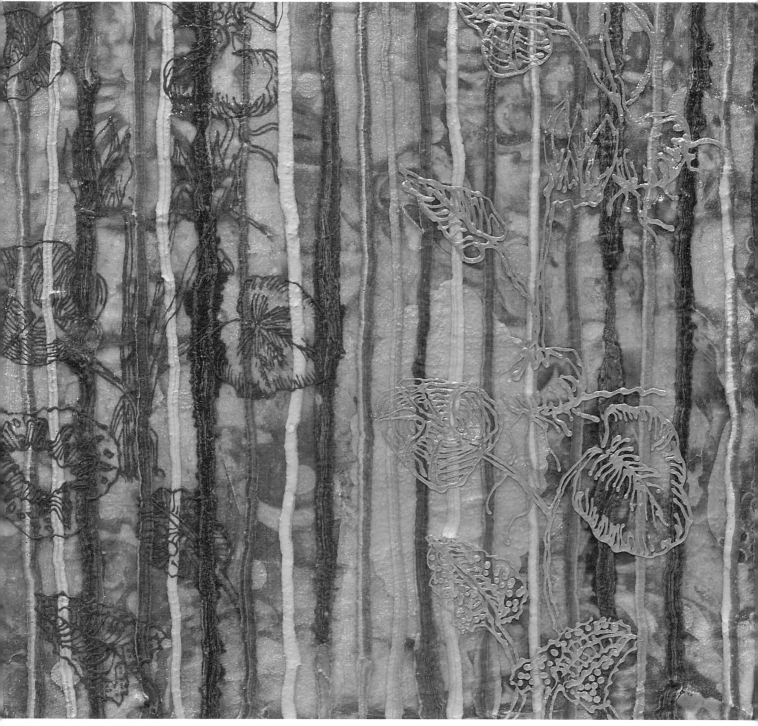

Seersucker Geraniums (Detail)
Patti Brady
Acrylic on wood panel

what is acrylic?

Pigments, such as Ultramarine Blue and Quinacridone Magenta, are the same for all types of paint mediums, but the binders are different. For oil paint the binder is linseed oil, for watercolor it is gum arabic. The binder for acrylic products is technically called a polymer dispersion.

The polymer dispersion is basically a mixture of microscopic spheres of clear plastic suspended, or dispersed, in water. As the water evaporates the plastic spheres move closer together, touch and bond, creating an acrylic paint film. As the acrylic dries, the pigments become trapped in the film. The acrylic binder (polymer dispersion) acts as a glue, attaching the pigment to the canvas or paper. In this form, the acrylic is white when wet but dries to a glasslike clarity.

So what is complicated about that? For most artists, this explanation will take you a long way in your exploration of acrylic painting, but for artists who continually want to push the envelope, there's a cornucopia of materials coupled with a world of technical information to investigate.

The manufacture of a professional-grade acrylic requires highly specialized chemists and curious, determined minds willing to test and reformulate acrylic to achieve the optimum combination of pigment, binder, stability and longevity. To achieve this optimum formulation, professional-grade acrylics include things like biocides, coalescing agents, surfactants and defoamers. In addition to this complicated balance, each individual pigment has its own unique recipe for formulation.

categories of acrylic
Acrylic can be separated into several categories:

Paint
This category includes all the different paint viscosities of acrylic with color pigments. These include heavy body, fluid, Airbrush and OPEN acrylics.

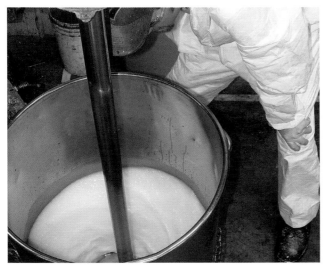

mixing the water, solvents and thickeners
Paint-making requires a liquid of various ingredients, water and detergent that will "trick" the dry pigment into a dispersion.

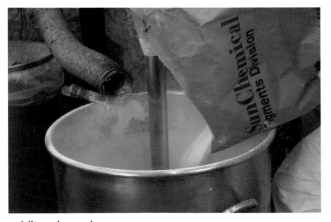

adding pigment
Here pigment is added to the mixture, creating the dispersion of water, solvents and thickeners.

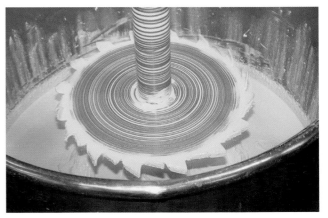

mixing the pigments and dispersion
The dispersion is mixed at 91 miles per hour to achieve a fairly homogeneous mixture.

Mediums

Mediums are acrylics without pigments. Gels and pastes are a subset of mediums. Mediums, gels and pastes are all designed to mix with paint.

Fluid Mediums are mediums that are thin and pourable such as Polymer Medium (Gloss), Matte Medium, OPEN Acrylic Medium (Gloss) and Acrylic Glazing Liquid. Mediums are typically used to change or extend your paint and to make glazes.

Gels are basically colorless paints. They are thick and range from transparent, semi-transparent and opaque. They can also be filled with particulate matter. Examples of gels include Heavy Gel (Gloss), Soft Gel (Matte), Clear Granular Gel, Coarse Pumice Gel and Self Leveling Gel.

Pastes contain marble dust, clays or other fillers resulting in a white or clay finish and are usually opaque and used to create texture. Some examples include Fiber Paste, Molding Paste and Coarse Molding Paste.

Additives

Additives have no acrylic binder so there's a limit to how much additives you can mix with paint. There are three additives: Acrylic Flow Release (water tension breaker), retarder and OPEN Thinner (both retarder and OPEN Thinner slow acrylic's drying time).

Gessos

Think of gesso as the bridge between the support and your paint. White gesso and black gesso fall into this category.

Grounds

A ground is a product that provides a desired surface on which to paint. Grounds can provide a surface to apply pastels, watercolor or other products. Examples of grounds include Absorbent Ground, Acrylic Ground for Pastels and Digital Grounds.

Varnishes

Varnishes are designed to be the final protective coating for a painting. They should be removable and add UVL protection. Polymer Varnish, MSA Varnish and Archival Spray Varnish are in this category.

the mixture being milled smooth
Once mixed, the dispersion is milled smooth through three heavy steel rollers that each weigh 900 pounds (1890gsm). This process reduces solid clumps of pigments to particle size.

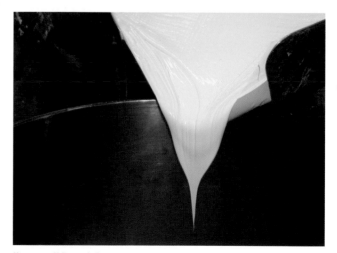

adding acrylic binder
Here the acrylic binder is added along with other materials to create a consistent product.

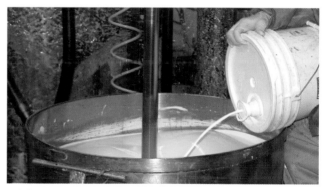

the result is paint
The mixture goes back to the milling process so the disperson and acrylic are blended together, ensuring the homogeneity of the final product—Heavy Body Hansa Yellow Medium.

options in paint viscosities

A paint's viscosity simply refers to how thick or thin that paint is. Thin paints are said to have a low viscosity, while thick paints have a high viscosity. Let's look at the options in acrylic paint, beginning with the thinnest, or lowest, viscosity.

··· **Airbrush colors** have a low, ink-like viscosity and dry slowly because they need to move through an airbrush without clogging it. They're magnificent for staining canvas and as watermedia. Next time you want an extremely fine line, use Airbrush colors.

··· **Fluid acrylics** have a thin, pourable viscosity with an equally strong pigment load to heavy body acrylics.

··· **Matte fluid acrylics** have matting agents added to them, creating low-viscosity paints that dry to a flat, gouache-like finish.

··· **OPEN acrylics** have a creamy viscosity for applying thin layers of paint used in traditional blending techniques. OPEN acrylics stay wet for longer periods of time.

··· **Heavy body acrylics** have a high viscosity that's designed to hold a brushstroke and spread like butter with a palette knife.

··· **Matte acrylics** are a version of heavy body acrylics that are designed to dry to a matte finish that will hold a brushstroke.

heavy body acrylics

A substantial viscosity, rich with pigment and free from fillers or matting agents, is the hallmark of heavy body acrylics. The creamy quality of these paints makes them one of the most popular types of acrylics.

fluid acrylics

A gorgeous pour of Pyrrole Red shows off the liquid viscosity of fluid acrylic paint. Fluids are a great solution for artists who want to create a smooth paint surface. If you're always thinning down heavy body acrylics, then fluid acrylics might provide the viscosity you're looking for.

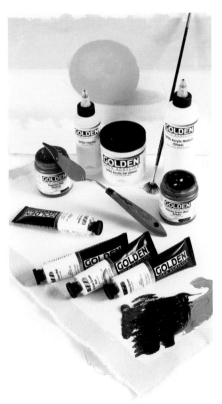

OPEN acrylics

Because OPEN acrylics are created with a unique polymer, they are well suited for blending and can sit on a palette for days without drying. They can be mixed with all types of gels and mediums.

know your pigments

There are two chemical classifications of pigments: the technical terms are *organic* and *inorganic*. However, it's easier to distinguish these pigments by their nicknames: *modern* and *mineral*.

modern (organic) pigments

These pigments are generally translucent and have a high chroma. Modern pigments also have a high tinting strength (think Phthalo Blue) and make very clean, bright glazes.

mineral (inorganic) pigments

Mineral pigments are easy to recognize because they have names that reflect their origins, such as Sienna, Oxide, Umber and Ochre. These pigments have a relatively low chroma, a low tinting strength and are generally opaque.

Modern (Organic) Pigments

Hansa Yellow Medium

Phthalo Blue (Red Shade)

Quinacridone Red

Quinacridone/Nickel Azo Gold

Permanent Violet Dark

Phthalo Green (Yellow Shade)

Quinacridone Violet

Mineral (Inorganic) Pigments

Cadmium Yellow Dark

Cerulean Blue Deep

Cadmium Red Medium

Raw Sienna

Ultramarine Violet

Chromium Oxide Green

Violet Oxide

organic and inorganic pigments

Comparing similarly colored pigments side by side reveals their differences.

pigment reality

Knowing the differences between modern and mineral pigments is essential for successful color mixing. Mineral pigments, partly due to their opacity, make mixtures of a lower chroma than mixtures made from the modern family. This isn't color theory, but pigment reality. Acknowledging this will give you control over your color mixing choices.

use professional-grade paints

Professional-grade acrylics are simply not what they used to be. They have higher pigment loads, and, if fillers are used at all, they are used only to produce unique formulations, not to fill up space or reduce the cost. By selecting professional-grade acrylics, you'll get more pigment for your investment, allowing you more ways to manipulate your paint with gels and mediums. The color will mix more easily and will not shift as much as it dries. Lastly, the binder of professional-grade acrylic paints is designed with the goal of making them resistant to chemical changes resulting from reactions with oxygen, water and exposure to ultraviolet light. While it's not known how long acrylic films will retain their physical qualities, current tests suggest they will last hundreds if not thousands of years.

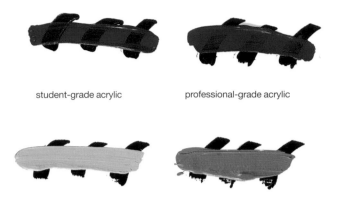

student-grade acrylic professional-grade acrylic

student vs. professional acrylics

Here you can see the difference between student-grade Naphthol Red Light and professional-grade. Notice the transparency of the student-grade paint compared to the professional-grade. In the second row, 1 part red has been mixed with 10 parts Titanium White. When the pigments are mixed with white, the considerable difference in pigment load becomes obvious.

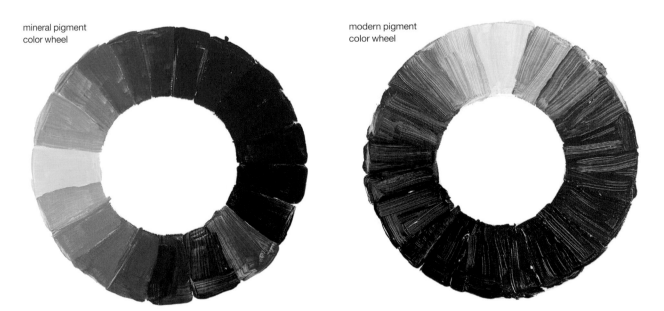

mineral pigment color wheel

modern pigment color wheel

pigment control

Each of these color wheels was made by mixing three primary colors. The mineral pigment color wheel used Cadmium Yellow Medium, Cadmium Red Medium and Cobalt Blue. The modern pigment color wheel used Hansa Yellow Medium, Quinacridone Magenta and Phthalo Blue (Red Shade). Notice the translucency and brightness of the modern colors compared to the opaque, dull mineral mixtures. One is not necessarily better than the other, but knowing their differences will give you more control over your palette.

read the paint label

By federal law, all paint must be labeled with health and safety precautions. Read all the information on the label, though it can be confusing at times. Here's a simple and effective way to approach all art materials. First, consider how these materials can get into your body: inhalation, ingestion and absorption through your skin. Second, these materials are tested, but they are tested for use. "For use" with paints and gels indicates the expected use is that you take the paint out of a jar with a palette knife or brush and directly apply it to a surface. These products are not designed to be face paint, tattoo ink, hand cream or room deodorizer. When a label indicates that it's not toxic, it's assumed you will not eat it or finger paint with it.

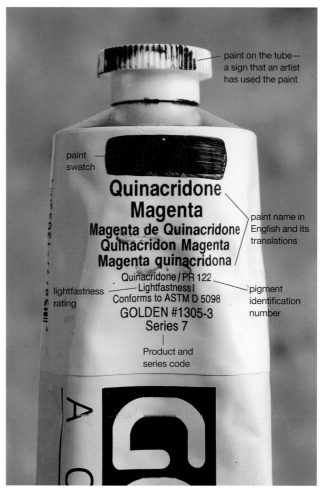

paint on the tube—a sign that an artist has used the paint

paint swatch

Quinacridone Magenta

paint name in English and its translations

lightfastness rating

pigment identification number

Product and series code

safety label

Through the American Society for Testing and Materials (ASTM) art materials are tested and labeled for chronic health hazards. It's essential that you follow the precautions listed on these labels. In other words, reading the label is important.

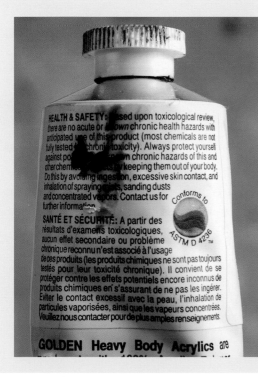

anatomy of a paint label

··· **Lightfastness rating** indicates if a pigment will fade or darken when exposed to long periods of ultraviolet light. A lightfastness rating of I (excellent) or II (very good) is considered suitable for archival paints.

··· **Paint swatch** is a hand-painted swatch of the Quinacridone Magenta over black lines, indicating the level of transparency.

··· **Pigment identification number** refers to the color index number. P is for pigment and R stands for red. The 122 is the color index number, which is useful if you are looking at different manufacturers and want the same pigment.

··· **Product codes** are used by all manufacturers to describe the color and size of a product.

··· **Series code** refers to the retail price for each series.

tools and tips

A plethora of implements can be used to move acrylic around on your painting surface.

··· **Palette knives**. These are great for mixing and applying paint. You can select either stainless steel or plastic. (Dried acrylic can be peeled off a plastic knife.) Even big cooking spatulas can be used as palette knives for applying paint to large areas.

··· **Brushes**. Select a variety of round, flat and filbert brushes in different sizes and handle lengths. Generally, use smaller brushes for smaller paintings and detailed work, and larger brushes for larger paintings and for laying in large areas. Synthetic bristles are handy for their range of stiffness and ability to sit in water for long periods of time. Wide, flat house-painting brushes are great for priming your surface with gesso. Faux-finishing brushes are handy for blending and special effects. Natural-hair brushes such as sable and mongoose are good for very smooth, oil-like blending, so keep a few on hand.

··· **Sponges**. Flat sponge brushes and sponge rollers can be used to create interesting textural effects.

··· **Additional tools**. Metal combs can be used to scrape in interesting textural surfaces. Window scrapers, paint scrapers and putty knives are handy for excavating layers or cleaning your palette. It's also good to have a spray bottle filled with water for misting your surface and another spray bottle filled with isopropyl alcohol, which will dissolve acrylic for unique textural effects. Have a selection of tapes on hand for masking off areas you don't want to paint, or for creating straight lines. Color shapers, available in a range of widths from very fine points to 5" (13cm) can be used to carve into the wet acrylic surface. Finally, always have a flat-head screwdriver on hand for opening gallon containers.

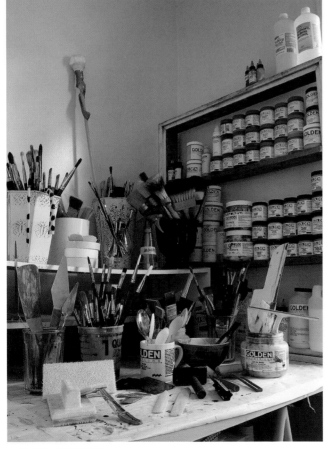

studio snapshot
You can get a lot of interesting paint applicators at hardware stores. Notice I keep my expensive natural-hair brushes in separate containers.

care of brushes

With acrylics, synthetic brushes or synthetic-blend brushes are best for everyday use and can be washed with soap or brush cleaners. Pay special attention to your expensive natural-hair brushes. Keep them separate from your regular brushes. Condition them with an inexpensive hair conditioner by rubbing a small amount into the filaments after use, then rub in a bit of conditioner for storage. Soak brushes that have become rock-hard in specially formulated brush cleaners.

drying time

The standard refrain about acrylics is that they dry too fast. For some painters, though, too fast is not fast enough. If you want

to speed up the drying time, let fans blow over the painting's surface. Or let the painting dry in a hot room, or under a heat lamp, or place a heating pad under the substrate. If you want a longer open time (*open time* is how long the paint is workable), consider using OPEN acrylics (for thinner layers) or working in cooler temperatures. You could also use thicker applications of paint and gels or mix Acrylic Glazing Liquid or retarder into your paint.

substrates

When working with acrylics, almost any surface can act as a substrate, including canvas, paper, wood, ceramic, bisque ware, Masonite, fiberglass, Plexiglas, and—with proper priming—metals and glass. Wax, surfaces with oil paint, unprimed metal, and water-sensitive surfaces are the few substrates that are not recommended for use with acrylic.

preparing the substrate

As with most paints, the most critical factor in obtaining a good adhesion between the paint and the substrate is to properly prepare the substrate. A quick rule of thumb is to apply two thin coats of GAC 100 allowing each layer to dry thoroughly before applying the next. Then apply two to three coats of gesso, also letting each layer dry before applying the next.

preventing support induced discoloration (sid)

During acrylic's drying time, water moves back and forth between the paint and the painting support and actually pulls the "dirt" of the support into the paint layer. To prevent this, the best practice for acrylic painters is to prime any painting support with two coats of GAC 100 before applying gesso. Common art supports, such as cotton and linen canvas, Masonite and some papers, contain water-extractable materials that can discolor transparent glazes or thick gel applications.

environmental studio practices

Always dispose of acrylic paint in a dry form; don't wash acrylic down the drain. Wipe your tools with paper towels to take off as much paint as possible before washing.

Wash brushes in a container, then pour the water you used to clean the brushes into a gallon bucket and let the water evaporate. Peel the layer of pigment and dried acrylic from the bucket's sides and bottom and throw the chips away.

dispose of acrylic in dry form
As the dirty water evaporates, it creates strata of dry pigment. It's better to dispose of these dry chips than diluted paint.

watermedia
effects

THIS CHAPTER IS ALL ABOUT WATER,

washes, stains, bleeds and blooms. It's about taking time-

honored watercolor techniques and "blowing them out of

the water." Using acrylic gels and grounds, you can create a

variety of surfaces with varying degrees of absorbency that

will allow you to put acrylic on numerous substrates. We're

not talking just paper or canvas anymore—now you can use

wood, ceramics, Plexiglas and metals. Almost any surface

can be made to accept acrylic, giving us an embarrassing

number of porous surfaces to paint on.

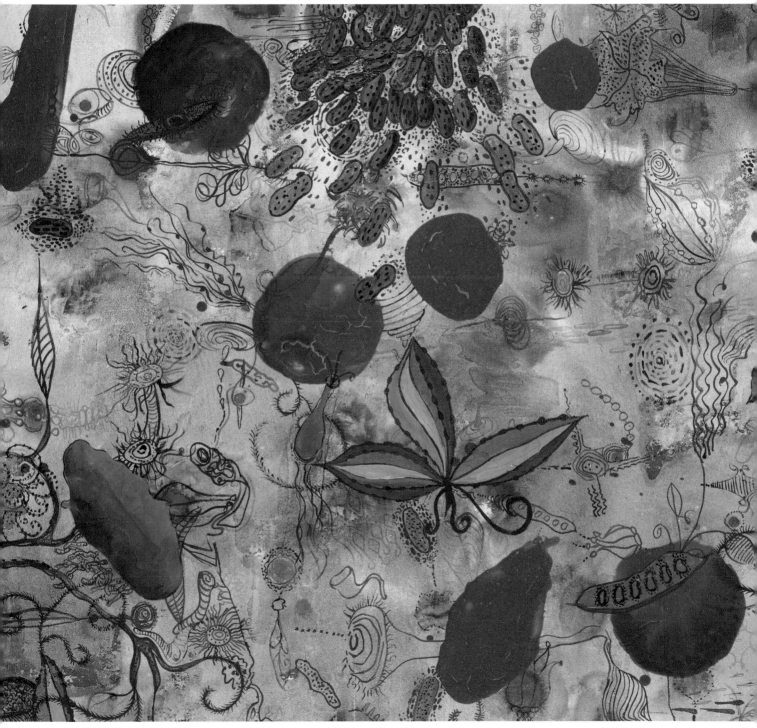

Peachy Keen (Detail)
Patti Brady
Acrylic on canvas
Collection of Countybank

maximizing washes

fluid acrylics

Acrylics must be thinned with water to create a wash consistency, and the very best acrylics to dilute are fluid acrylics. These are thinner in viscosity than heavy body acrylics, yet they have the same amount of pigment per ounce, requiring significantly less water to achieve rich, vibrant stains.

Acrylics are great for multilayered washes. Since they aren't resoluble (like watercolor), they will not lift and remix with the new wash and will hold a tight, clean edge.

staining and granulating pigments

Watercolorists who are familiar with pigments that stain and granulate will find that acrylics act in much the same way. Inorganic or "earth" pigments are heavier, and when suspended in water on a highly absorbent surface, will float out into the larger crevices of the surface. Organic pigments will stain into any and all microscopic pockets.

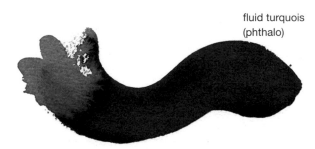

fluid turquois
(phthalo)

fluid vs. heavy body acrylics
Heavy Body Turquois (Phthalo) was thinned with enough water to create a wash on watercolor paper. The Fluid Turquois (Phthalo) took much less water to reduce it to a wash, creating a richer and denser stain.

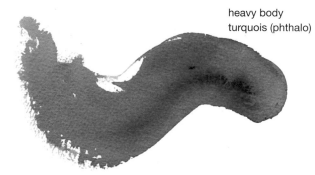

heavy body
turquois (phthalo)

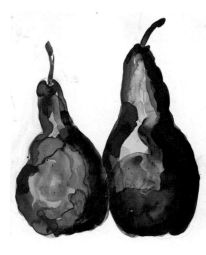

fluid acrylics retain their brilliance
These pears were painted with several layers of thinned fluids. Each separate wash retains its brilliance and doesn't muddy or lift the color of the wash underneath.

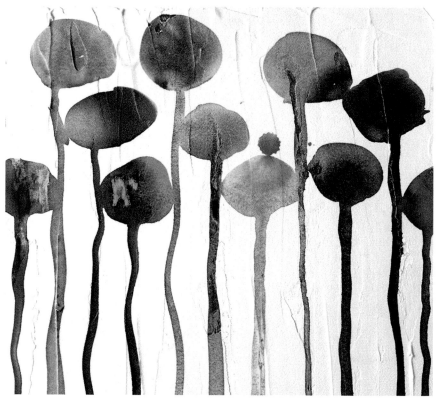

staining and granulating pigments
Each "mushroom" is a mixture of a granulating pigment and a staining pigment. The surface is a dry layer of Light Molding Paste, which is a crisp white and highly porous surface that's great for staining and watercolor wash techniques.

grounds for staining and washes

To stain with acrylic, consider the pigments and paint viscosity, then choose a ground with the appropriate absorbency and texture. There are myriad surfaces that you can choose to stain, wash or bleed color into.

Although there are specific products that are designed as grounds, any gel medium can be used. There are thirty-four unique gels and grounds. Each has a unique surface quality that affects the wash applied to it. To explore the possibilities, tint each type of gel with one color, then apply the washes, creating a set of samples for your reference.

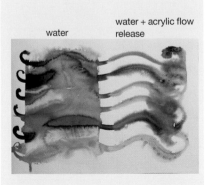

Coarse Pumice Gel: Creates a chunky gray surface that's highly porous and absorbent

Glass Bead Gel: Translucent glass beads with a pebbled surface

Coarse Molding Paste: Makes a crisp, bright, slightly translucent and porous white surface with a grainy texture

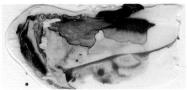

High Solid Gel (Gloss): Creates thick, stiff texture with a transparent, glossy surface

Crackle Paste: Dries white and opaque with cracks sized in proportion to the thickness of the application

Fiber Paste: Creates a paperlike surface that's white and opaque

Light Molding Paste: Bright white, highly porous and very absorbent

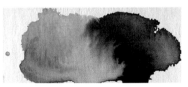

Absorbent Ground: The watercolorists' gesso creates a smooth, white surface

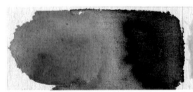

Acrylic Ground for Pastels: Translucent, with a great tooth for capturing sharp-edged washes

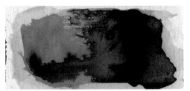

Fine Pumice Gel: Fine sandlike grains; slightly gray with a subtle tooth

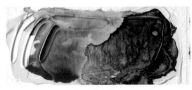

Molding Paste: Dries slightly gray and opaque; creates a smooth, almost nonporous surface

Garnet Gel (Fine): Rosy brown, translucent garnet beads create a beautiful violet with blue wash

Heavy Gel (Matte): Dries translucent and has a subtle tooth

Matte Medium: Low-viscosity transparent gesso; adds tooth with no texture

absorbent ground on panel

Let's take a closer look at one of the grounds and exploit its properties. We'll use Absorbent Ground (White), a product designed specifically for watercolor artists who want to work on larger surfaces than current watercolor paper sizes allow, or who want to reproduce watercolor effects on unusual substrates. You can tint Absorbent Ground to create toned grounds that are unavailable in manufactured surfaces. The following example is a combination of varying applications and techniques, wet-into-wet, sanding, masking, stains, blended washes and opaque applications.

materials

FLUID ACRYLICS
Cerulean Blue Deep, Cobalt Teal, Cobalt Turquois, Green Gold, Indian Yellow Hue, Naphthol Red Light, Raw Umber, Titanium White, Ultramarine Blue, Vat Orange

TOOLS
1½-inch (38mm) synthetic flat brush, masking fluid, no. 12 synthetic round brush, palette knife, rag, sanding block, soft eraser (for removing masking fluid)

SURFACE
Wood panel

OTHER
Absorbent Ground, Acrylic Flow Release, white gesso

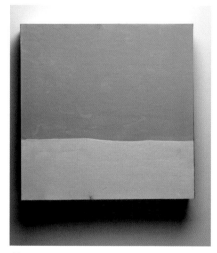

1 establish the ground

Prime the wooden panel's surface with two coats of gesso and let it dry. Mix 9 parts Absorbent Ground with 1 part Cobalt Turquois and apply four coats of this to the top two-thirds of the panel for the sky. Allow each coat to dry before applying the next coat.

Mix 10 parts Absorbent Ground with 1½ parts Indian Yellow Hue and apply four coats of this to the bottom third of the board to create the water. Allow each coat to dry thoroughly. If the surface feels cold, it's not dry yet.

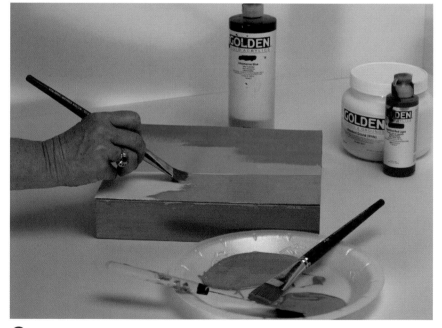

2 vary the color

Tint the Absorbent Ground by mixing 10 parts Absorbent Ground with 1 part Ultramarine Blue and apply a final layer to the sky. Mix 10 parts Absorbent Ground with 1 part Naphthol Red Light and apply this to the water area. Allow each coat to dry thoroughly. Because the final top layer of Absorbent Ground is a different color, you can reveal strong contrasts as you sand back to lower levels.

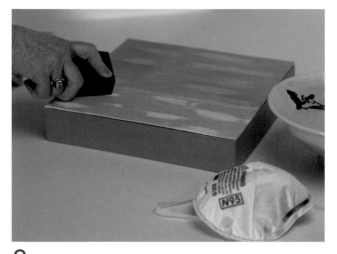

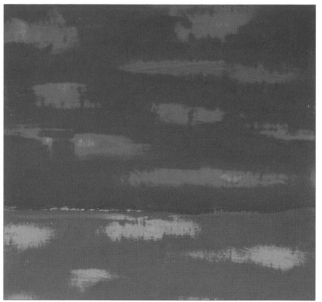

3 wet-sand the surface

Brush clean water over the surface with a flat brush. Sand in horizontal shapes across the entire surface with a sanding block to reveal the pigments below. Wear a mask and do not dry sand. When you're finished sanding, clean the surface with a damp rag and let it dry.

sanding back adds interest and depth

The rough areas created by sanding could not have been achieved by applying paint on top of paint, but only by sanding back. This process adds interest and depth to the painting.

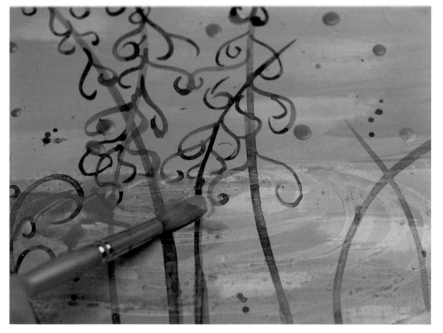

4 develop the surface

Paint tree images on the surface using varying mixtures of Ultramarine Blue and Raw Umber thinned with water. Notice how the dry surface of Absorbent Ground helps control your brushstrokes.

Let the trees dry, then paint circular ripples of water over the pink area with masking fluid. The masking fluid will protect the pink color from subsequent layers. Add random drops of masking fluid to the sky area. Let dry.

Mix 10 parts water with 1 part Acrylic Flow Release in a separate container and cover the entire surface with this mixture. Thin the Cobalt Teal with water to a watercolor consistency and wash this over the dry masking fluid ripples in the pink area. Then wash in thinned Green Gold, Titanium White and Cerulean Blue Deep in the sky area. Let these colors bleed together.

absorbent ground

Absorbent Ground is a bright white "gesso" that imparts a paperlike surface wherever it's applied. It's ideal for watercolorists who want to go beyond watercolor paper. Apply Absorbent Ground to any surface that acrylic adheres to or that can be primed for acrylic application.

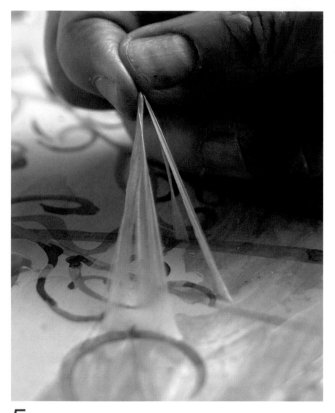

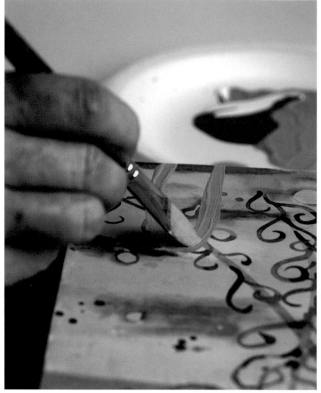

5 remove the masking fluid

Once the surface is dry, remove the masking fluid. Use an eraser to help you lift up the masking so you can then peel it off.

6 add opaque colors

Add some opaque paint layers to play off the transparent washes underneath. I made the circles with a mixture of Vat Orange and Titanium White.

using masking fluid

Watercolorists use masking fluid to retain white areas on their paper. It comes in several colors, and has the feel of rubber cement. When dry, it can be easily peeled from your paper. Never use good brushes to apply masking fluid, and read the manufacturer's directions carefully.

the next step is up to you

There are many possibilities open to you at this point. You could continue to sand back areas, do more washes and add more layers of masking fluid.

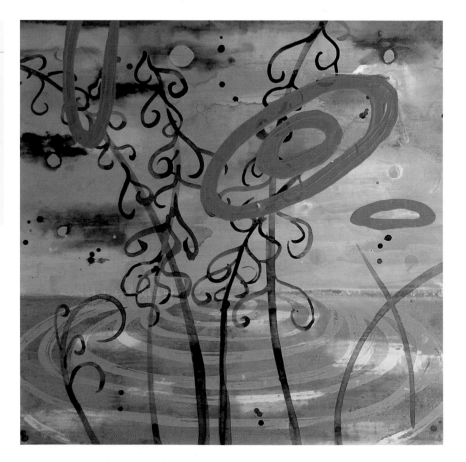

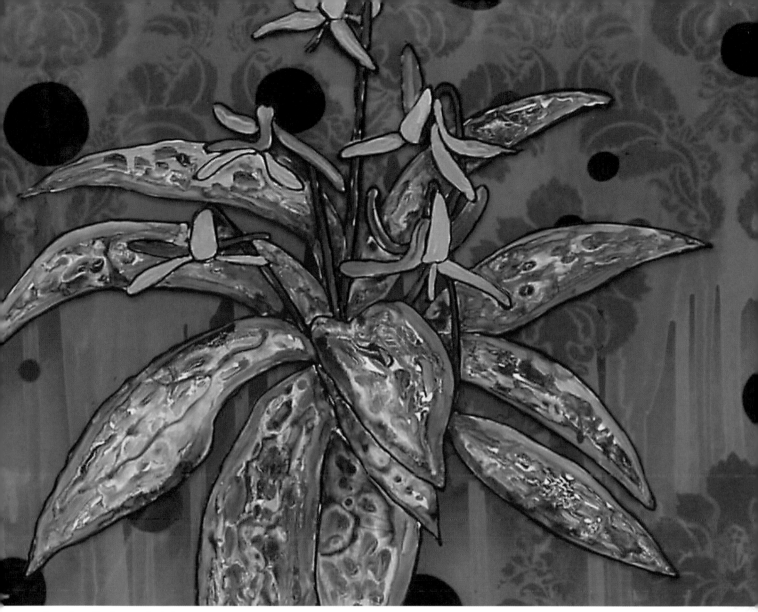

watercolor effects on plexiglas

The leaf areas of this painting on Plexiglas were primed with Absorbent Ground. The Absorbent Ground allowed for specific areas to be primed for a wet-into-wet application of fluid acrylic, which gave me the particular blooms and bleeds that I needed to re-create the dappled quality of color on the leaves. It's great eye candy: the stains on the bright white surface contrast with the high gloss of the Plexiglas.

Toad Lily (Detail)
Patti Brady
Acrylic on Plexiglas
Collection of Whole Foods, Inc.

sealing absorbent ground

The extreme absorbency of the Absorbent Ground surface requires that it be sealed to keep it free from dust and dirt. (See chapter 12 for details about varnishing.)

translucent watercolor-like washes

In this demonstration you'll create two layers with different textures and absorbency using the unique properties of two different gels: Heavy Gel (Gloss) and Heavy Gel (Matte).

Heavy Gel (Gloss) is a very stiff gel that will hold textures created with a palette knife or brush. The matte sheen of Heavy Gel (Matte) is produced by adding a matting agent (fine white silica), which both adjusts the sheen and gives the gel a more absorbent surface.

materials

FLUID ACRYLICS
Diarylide Yellow, Quinacridone Red, Titan Buff, Turquois (Phthalo), Ultramarine Blue, Vat Orange

TOOLS
No. 6 synthetic filbert brush, palette knife, paper towels

SURFACE
Rigid substrate such as canvas, heavy paper or wood panel

OTHER
Heavy Gel (Gloss), Heavy Gel (Matte)

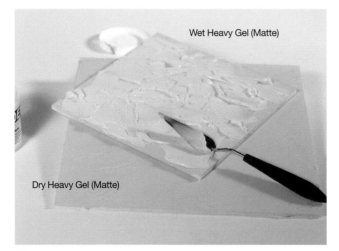

Wet Heavy Gel (Matte)

Dry Heavy Gel (Matte)

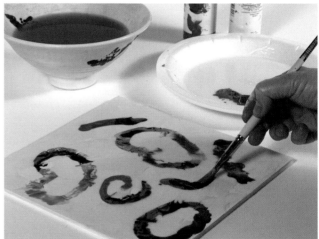

1 prepare the substrate
Mix 1 part Diarylide Yellow with 1 part Titan Buff and apply a basecoat of this to the surface. When this is dry, spread Heavy Gel (Matte) over the surface with a palette knife, creating textures by pulling and pushing the gel. Heavy Gel (Matte) is white when wet, but semitranslucent when dry.

2 add colorful shapes
With your brush loaded with clean water, draw shapes (circles, ovals and kidney beans) on the surface. While the water is still wet, load your brush with thinned Turquois (Phthalo) and dip the brush into one side of the wet shape. Let the color move around in the water, or gently nudge it with your brush. The color will move in the water but stop at the edge of the shape. Clean your brush and add thinned Vat Orange to the opposite side of the shape. Let the colors bleed together, creating different color mixtures as they settle into the gel's crevices. If you make a mistake, blot the color with a wet paper towel, let the surface dry, and do it again. Let this dry.

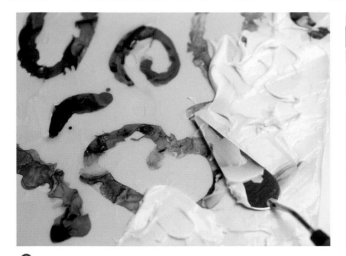

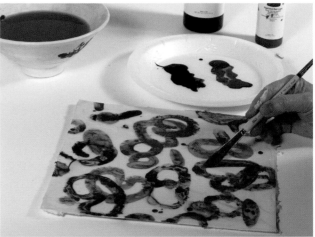

3 add texture with heavy gel (gloss)

Use a palette knife to spread the Heavy Gel (Gloss) over the entire surface, creating some texture. Create a layer ⅛- to ¼-inch (3mm–6mm) thick. The gel will be white when wet, but will dry clear and very glossy. As the water evaporates and the gel dries, it will shrink, so don't be shy in your application.

4 add another layer of colorful shapes

Add a second layer of shapes on the glossy surface, using the wet-into-wet technique from step 2. This time, drop in Quinacridone Red and Ultramarine Blue and move the colors around with your brush. Because this surface is so glossy and tight, the acrylic will crawl and separate. Allow it to do its magic.

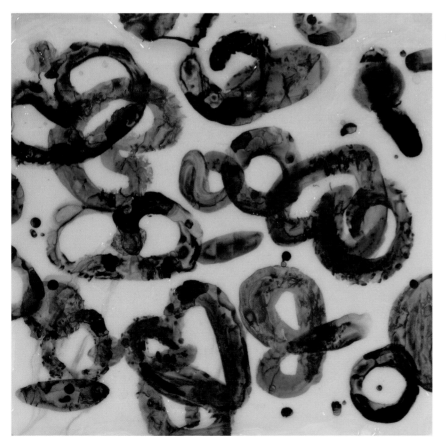

layers of broken color

The final image has layers of broken color sitting on different surfaces. The top surface is quite glossy and thick, creating visual spaces between the washes. The washes themselves are affected by the different surfaces, which add a curious quality to the shapes.

examples of watermedia effects

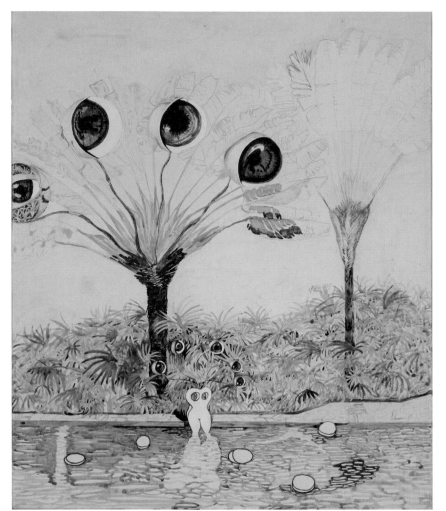

absorbent ground mimicking hot-pressed paper

I love this quirky painting by Uzine Park, a South Korean artist living in Seoul. Her surface is a very smooth, almost polished application of Absorbent Ground, similar to hot-pressed watercolor paper. Colors were applied using fluid acrylics.

Afternoon of a Holiday
Uzine Park
Acrylic and colored pencil on canvas
18" × 15" (46cm × 38cm)
Photograph by Jo Young-Ha

watercolor applications with a twist

Miles Laventhall combined fluid acrylics in a traditional watercolor application but added a gritty black metallic gel, Black Mica Flake, to the surface. The mica was applied in a random pattern horizontally, then washes and pours with fluid colors were applied over the dry mica. Details were reworked with more Black Mica Flake and heavy body paints to finish the painting.

Birthing Ground
Miles Laventhall
Acrylic on linen
13" × 49" (33cm × 124cm)

Patti Brady

I spent a solid forty years living in coastal California cities—almost thirty years of that in San Francisco—a city of wide-open vistas and fresh ocean breezes. When I moved to South Carolina in 1999, the dramatic change in landscape affected me profoundly. *Peachy Keen* was inspired by that transition. Admittedly, all of my work ASF (After San Francisco) was influenced by the new milieu. In San Francisco, we had a few flies and maybe a spider or two, but in South Carolina the air and ground are filled with flying things that dive-bomb, bugs that buzz, beetles, chirping crickets, cicadas, tree frogs, one hundred species of spiders, a few thousand mosquitoes and no-see-ums. Add to that mildew, humidity and thunderstorms! In the spring, plants, weeds and kudzu grow at incredible speeds. It's all slightly claustrophobic and overwhelming for a coastal Californian—you'll get the drift and the feeling from the painting.

My painting process is one of discovery throughout. I never begin a painting expecting a specific outcome. I might have ideas in mind, but I am totally open to excavating the painting from the materials and from my own images. I begin most paintings with a free and exploratory layering of different gels. As my experience has grown, I often have an idea of how some of my processes will work, but I always remain open to the mistake that wasn't planned. That is more exciting to me than planning out each idea.

Patti in her studio with Aggie Lee

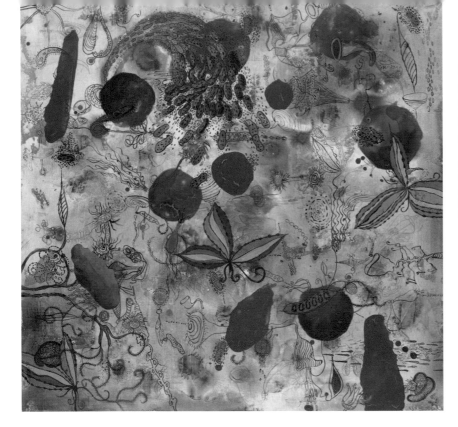

Since I am not sure whether the painting will eventually have thirty-nine layers or three, it's imperative to begin with a sturdy, ridged substrate for the paint application. I prefer Ampersand's cradled panels.

Peachy Keen
Patti Brady
Acrylic on canvas
36" × 36" (91cm × 91cm)
Collection of Countybank

I prime any substrate with two coats of GAC 100, followed by two coats of gesso to prevent any support induced discoloration (SID) in the future. I painted an imprimatura (a thin glaze that's used as an underpainting) of reds and oranges—Pyrroles, Naphthols and Naples Yellow Hue—on the surface and sides of the panel. When dried, I then spread Light Molding Paste over the entire surface, creating ragged edges on the sides, and leaving some of the imprimatura uncovered. I wanted some texture so I used the palette knife to make a funky surface.

staining the surface

Here I'm staining the surface with different layers of Quinacridone/Nickel Azo Gold, Quinacridone Red Light and Micaceous Iron Oxide, Zinc White and Transparent Pyrrole Orange. Usually, I dampen the Light Molding Paste with water from a spray bottle before staining. You can see the stain beginning to bleed in the bright orange areas.

darkening the surface

I thinned Micaceous Iron Oxide with water to stain and darken areas on the surface.

painting detailed drawings with airbrush color

Airbrush colors are the perfect viscosity for these thin watercolor lines, so I don't have to spend time thinning my fluid acrylics with water. These paints are very thin, but contain plenty of pigment for dark, fine precise lines. The absorbency of the Light Molding Paste enhances the watercolor look.

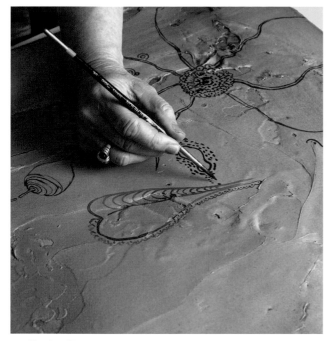

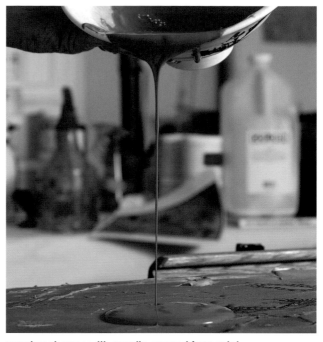

continuing the drawing

I created these "drawings" with a detail brush and varying mixtures of Airbrush Raw Umber Hue and Ultramarine Blue Hue for a rich, black line, or Burnt Sienna Hue for more of an earth tone. I used some Airbrush colors full strength and thinned out some others. The paint is so thin the lines appear to be under the surface, although all were painted on top.

I continued to draw and paint these quirky "bugs" and botanical absurdities until the entire surface was crawling with lines.

pouring shapes with acrylic ground for pastel

I wanted to break up the surface, so I added large circles and oblong shapes with pours over the detailed paintings. The large dark gray and orange shapes were achieved with a mixture of Micaceous Iron Oxide (for opacity) and Pyrrole Orange (for translucency) with Acrylic Ground for Pastels. I didn't thin the Acrylic Ground for Pastels because I wanted it to be very thick. The mixtures were simply poured on randomly. Some of the thick shapes cracked, as I anticipated. In some areas I poured this mixture over the lines, and then I worked back over the dry pours with a detail brush and more painting.

surface detail

Here you can see how transparent the pours with Acrylic Ground for Pastels are. The drawing is still visible through the surface. I added Interference Violet (Fine) to the Micaceous Iron Oxide mixture to get that weird but luscious color.

I continued to work on the painting, adding more opaque areas, more pours and more details until I felt it was jam-packed, with little breathing space left. I over-worked the peanut shapes, which had morphed into peapod shapes. They took on a life of their own, needing to be painted everywhere, and finally they exploded like fireworks.

creating texture with gels

GELS ARE THE ACCESSORY THAT MAKE ACRYLIC THE MOST VERSATILE MEDIUM AVAILABLE FOR painters today. The medium itself can drive your ideas. In this chapter, you will discover less-than-traditional ways to use acrylic gels and develop new ideas as different artists reveal their personal methods.

This chapter contains a wild mixture of step-by-step projects and some unfinished starter ideas to get your creative juices flowing. Finally, you'll visit K.D. Tobin's studio where gels, paint, brooms and feet all come together.

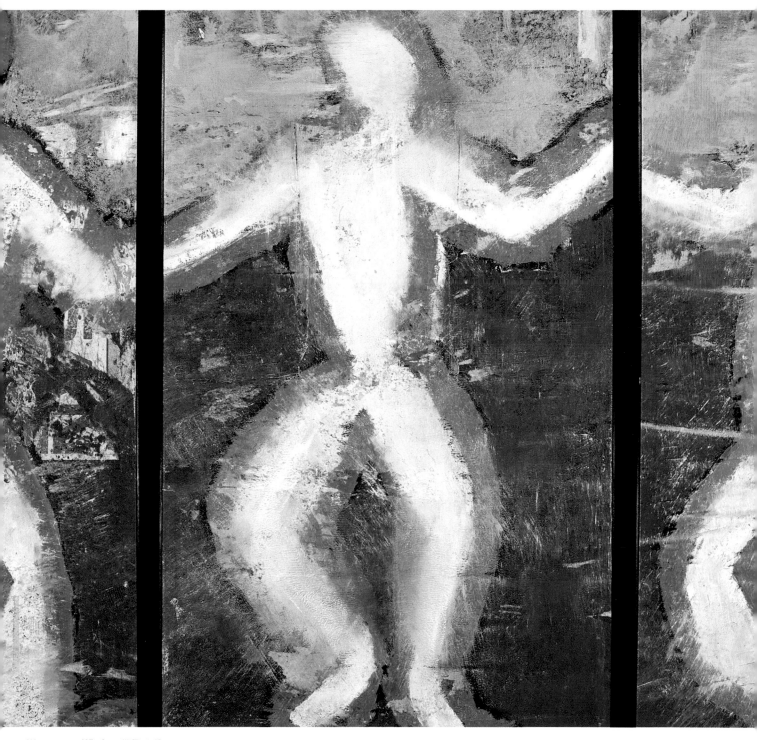

Woman on a Windowsill (Detail)
K.D. Tobin
Acrylic and mixed media on canvas
Private collection

selecting a gel

There is such a wild range of gels that it's difficult to know where to begin. Gels come in a variety of viscosities from the yogurt-like Soft Gel (Gloss) to stiff, pasty High Solid Gel (Matte). Gels can dry to a clear gloss, semigloss, satin or matte finish. There's also an array of particulate matter added to some gels, rendering them either opaque or gritty, and affecting their level of absorbency.

Gels added to paint can change the color or the sheen, add stiffness or fluidity, and create greater transparency or opacity. You can use gels to establish a gritty, absorbent ground or to give the surface a glassy sheen.

If you haven't used gels before, make a chart like the one on this page for reference. Use one color throughout (I used Fluid Cobalt Teal). This will show you how each gel affects mixtures with color, how it can be used as a ground, and whether it is transparent, translucent or opaque.

Tinted gel

Untinted gel

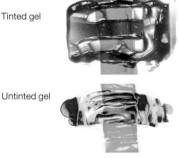

Soft Gel (Gloss) has a yogurt-like consistency. It dries completely clear, with a high gloss surface.

Regular Gel (Matte) has the same viscosity as heavy body paint. It's stiffer than Soft Gel, and dries to a frosted matte surface.

Light Molding Paste has the fluffy consistency of cake frosting. It's white, opaque and highly absorbent when dry.

Molding Paste is slightly gray and opaque. It dries to a smooth surface.

Tinted gel

Untinted gel

Coarse Molding Paste is a bit chunkier. It starts out white but becomes a bit translucent and porous when dry.

Fiber Paste is slightly off-white, with the consistency of paper pulp. It dries opaque, to a paperlike finish.

Glass Bead Gel dries to a clear, pebbled finish.

crackle paste on panel

Crackle Paste is an unusual, unpredictable gel that creates cracks in the surface film as it dries. The dry surface is very absorbent and useful for staining applications. The size of the cracks varies, based on the application's thickness. Here, my application was very thick, about ¼-inch to ½-inch (6mm–13mm).

Optimum drying conditions are between 65°F and 75°F (18°C–24°C), and under 75 percent relative humidity. A thick application may take three days to dry, resulting in large fissures that allow the basecoat to show through (thinner applications may dry overnight). Do not attempt to force the drying process with a hair dryer or fan. Each island created by the cracks will create a concave surface that you can exploit with paint.

materials

FLUID ACRYLICS
Burnt Sienna, Cerulean Blue Deep, Chromium Oxide Green, Cobalt Blue, Diarylide Yellow, Green Gold, Iridescent Stainless Steel (Fine), Micaceous Iron Oxide, Naples Yellow Hue, Payne's Gray, Prussian Blue Hue, Quinacridone/Nickel Azo Gold, Sap Green Hue, Transparent Pyrrole Orange, Yellow Ochre

HEAVY BODY ACRYLICS
Cobalt Titanate Green

TOOLS
Cotton swab, no. 10 synthetic round brush, palette knife, spray bottle with water, wide colour shaper

SURFACE
Gessoed panel or other rigid substrate

OTHER
Crackle Paste, Matte Medium

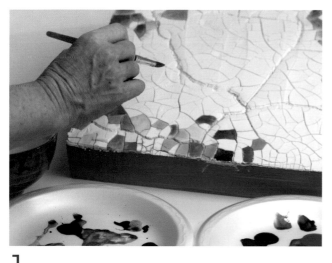

1 prepare the surface, then apply the paint

Apply a basecoat of Heavy Body Cobalt Titanate Green and let dry. With a palette knife, spread a thick layer of Crackle Paste over the basecoat and let dry.

Mist the surface with a spray bottle filled with water to increase the absorption. This may also cause the colors to bleed from one Crackle Paste island to another. (For more control, dampen each Crackle Paste island separately and blot up unwanted wet color with a paper towel or a cotton swab.)

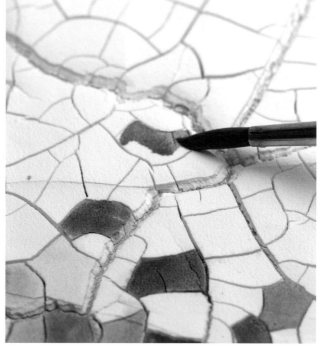

2 develop the design

Carefully create the shape of a face with warm skin tones of yellows, oranges and umbers.

3 finish with matte medium

Seal the surface with Matte Medium to retain the matte surface of this piece. Apply two to three coats, using a wide colour shaper to push the Matte Medium deep into the cracks. Allow each coat to dry between applications.

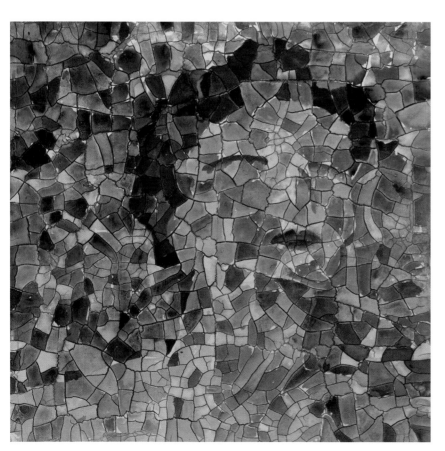

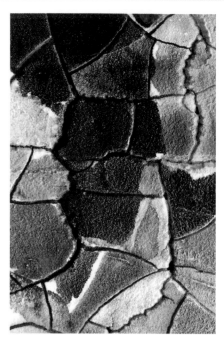

detail of stained surface
Here you can see how the stains settle on top of the individual chips. In areas where I wanted a more defined area, I painted the color into dry Crackle Paste islands to limit the bleeding.

exploiting the paint film

Although I love the cracked and broken surface that Crackle Paste produces—or any paint film that has curdled and cracked—a good paint chemist would label this a "failed paint film." Normally, paint should form one strong continuous film. With a crackled surface such as this, there's a possibility of pieces falling off, so seal the cracks together with Matte Medium. That will act as a grout, creating a more stable paint film.

a simulated mosaic
Careful staining of the Crackle Paste creates a work that resembles a ceramic mosaic.

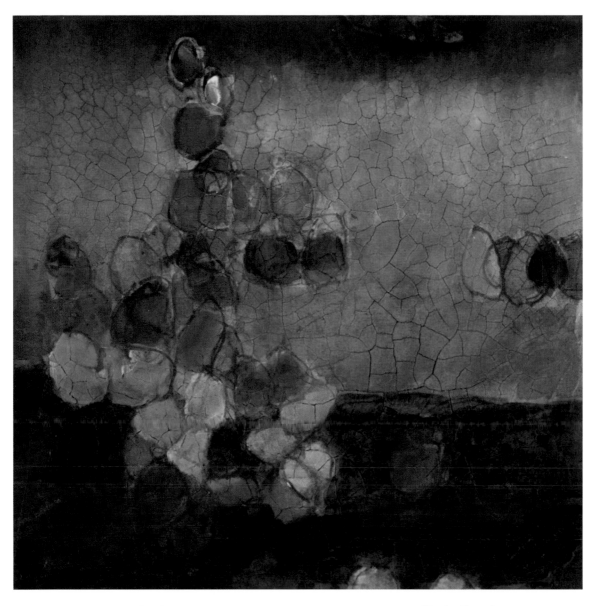

contrasting shapes and textures

In this painting, artist Bonnie Cutts used Crackle Paste on a maple board to create a crackled, absorbent surface to paint on. She applied multiple, thin, watercolor-like layers of fluid acrylics, then used graphite pencil to define the circular forms that move around the image. Layers of Fluid Matte Medium were applied to bring back tooth and to isolate the layers between the glazes. The Matte Medium was also used as a top coating to even out the sheen of the paints. Notice how the circular shapes play off the shapes created by the crackled surface.

Floating Upward
Bonnie Cutts
Acrylic on wood panel
10" × 10" (25cm × 25cm)
Collection of the artist
Photograph by Ed Bock

crackle paste on plexiglas

Here you'll use a transparent substrate, Plexiglas, and apply all the paint on the reverse side. There will be no paint on the front side of the Plexiglas when you're finished, so you'll need to think in steps that are the reverse of your normal paint application process. What you paint first will be literally on top, and your final application will be your background.

materials

AIRBRUSH ACRYLICS
Quinacridone Magenta

FLUID ACRYLICS
Cobalt Teal, Diarylide Yellow, Iridescent Stainless Steel (Fine)

TOOLS
1-inch (25mm) synthetic flat brush, hand-cut paper pattern in any shape, no. 6 synthetic flat brush, spray bottle filled with water, wide palette knife

SURFACE
Plexiglas, ¼-inch (6mm) thick

OTHER
Crackle Paste, Fluid Matte Medium

1 add opaque shapes
Place your paper pattern (this one is cut out of a piece of pink paper) under the Plexiglas and paint the shape using the pattern as a guide. (I held the Plexiglas at an angle so you could see the pattern.) Start with a simple shape and apply enough coats of paint to make it very opaque. (I used Diarylide Yellow and a no. 6 flat.) Instead of a cut pattern, you could put a drawing under the Plexiglas and use that for your design.

2 add more details and prime the surface
When the shape is dry, drip Fluid Iridescent Stainless Steel (Fine) onto the surface to create dots. While the drops are still wet, pick up the sheet of Plexiglas and let it fall flat on the table; this will settle out the dots and flatten them. When the dots are dry, apply a thin coat of Fluid Matte Medium with the no. 6 flat over the entire surface of the Plexiglas and let it dry completely. Fluid Matte Medium acts as a transparent gesso, giving the Plexiglas some tooth for the Crackle Paste to adhere to.

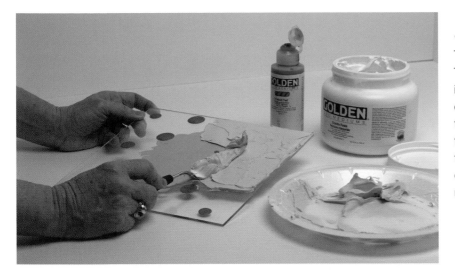

3 apply tinted crackle paste

Tint the Crackle Paste with Fluid Cobalt Teal. Do not mix more than 1 part color into 9 parts Crackle Paste or it will not crack. Using a wide palette knife, apply the Crackle Paste thickly in some areas for large cracks, and thinly in others for multiple small fissures. Let this dry overnight; the cracks will appear the next day.

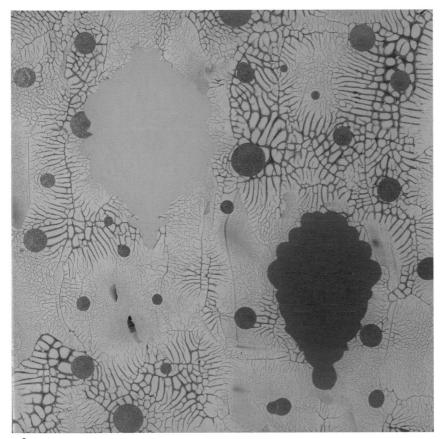

detail of the surface

The Airbrush color is working its way deep into the cracks. Remember, this is on the back of the image.

4 stain with airbrush acrylics

Dampen the surface with water from a spray bottle. While the surface is wet, use a 1-inch (25mm) flat to wash on Airbrush Quinacridone Magenta. It will take only a few minutes for the color to bleed deeply into the cracks. Carefully peek at the other side to see if you've added enough color. If so, allow it to dry thoroughly. When all tackiness is gone, apply several coats of Fluid Matte Medium to the painted surface to seal the cracks.

airbrush acrylics take longer to dry

Airbrush acrylics are designed to stay wet longer so that they do not clog an airbrush tip. Because of this, they take longer than normal to dry. Depending upon the application's thickness, drying could take several days.

gels with granular additives

I've always loved the look of the gritty, chunky gels, but they can be perplexing to use. Here are some ideas for using these gels in your paintings.

pumice gels

Pumice gels have been on the market for many years. These gels are filled with volcanic matter or sand in varying sizes. They dry to a concrete gray, although Fine Pumice Gel dries translucent when applied thinly.

For this first example I chose the extreme chunkiness of Extra Coarse Pumice Gel. The pumice chunks are peppered with porous cavities that create a highly absorbent surface when dry.

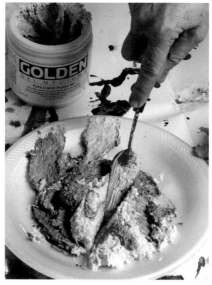

mix the gel with color
Here Fluid Cobalt Teal is mixed with Extra Coarse Pumice Gel. Stop mixing before the Cobalt Teal becomes homogeneous, and allow some of the pumice chunks to retain their gray hue for a richer and more complex color when dry.

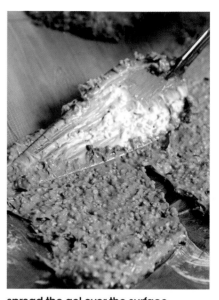

spread the gel over the surface
Spread the mixture with a palette knife over an underpainted surface. (I used an old painting that wasn't interesting anymore.) Use the point of the palette knife to carve out some lines from the original image. By applying an intensely textured and unusual surface, you create a "painting problem" that calls for resolution.

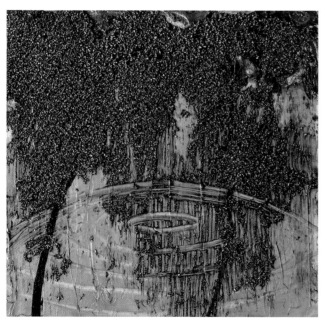

contrasting textures
The thick Pumice Gel sits high atop the underpainting, creating strong shadow and contrast. The high gloss of the painted surface contrasts with the matte surface of the pumice, suggesting a wall of water cascading down the painting.

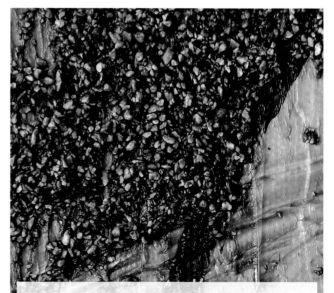

detail of dry extra coarse pumice gel
In this closeup, you can see that some of the Extra Coarse Pumice is still gray. Avoid over-mixing so the granules will vary in color. At this point, you could continue to add glazes or apply other colors and gels.

clear granular gel

The Clear Granular Gel is just as chunky as Extra Coarse Pumice Gel, but it's filled with chubby pieces of a translucent polymer. When dry, it resembles an ice-covered, snowy landscape.

Options for Clear Granular Gel

Use this surface as a starting point for one of your paintings. You could:

··· Drybrush over the textured surface.

··· Level the surface with layers of Clear Tar Gel (see page 88) or Self Leveling Clear Gel.

··· Add washes in lighter values.

··· Draw with oil pastels.

··· Use a squeegee to push gel or paint into the surface.

··· Paint with thick brushstrokes of heavy body paint.

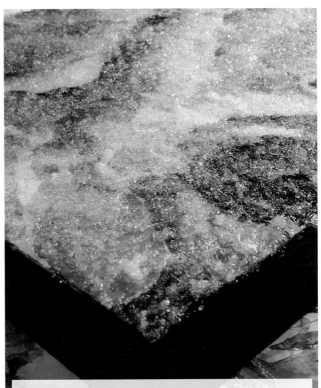

try clear granular gel over an old painting
I used an old painting for the base and applied a layer of Clear Granular Gel over the entire surface. Because Clear Granular Gel dries translucent, you can still see the remnants of a California oak tree under the dry layer of gel.

stain the surface
Try using Airbrush Ultramarine Blue Hue paint to stain the surface. Because the airbrush color has an ink-like viscosity, it bleeds deeply into the irregular surface, puddling in the deepest parts and sliding off the peaks.

vary the saturation
Vary the paint saturation by applying the Airbrush acrylic thinly in some areas and more deeply in others. It will look like a blueberry snow cone.

add different colors
Drip Airbrush Quinacridone Magenta directly onto the surface. The color will bleed out through the hollows and valleys, creating a radiating spider web.

garnet gel

Garnet Gel is actually made with mined almandine garnet, which is an earthier color than the garnets found in jewelry. You can select from Fine, Coarse and Extra Coarse Garnet Gel. Garnet Gel (Coarse) is very similar to Glass Bead Gel, but the small, transparent orbs vary in color from an earthy brown to a rosy pink.

wet garnet gel

An open jar of Garnet Gel (Coarse) ready to be applied. The gel is white when wet, but dries clear.

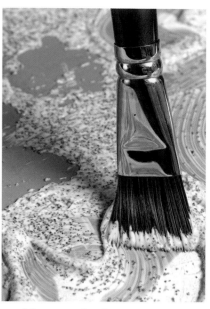

applying garnet gel

Spread Garnet Gel (Coarse) over the surface with a painting knife, then use a brush to swirl through the gel to create a pattern.

drying brings out the red of the garnets

As the gel dries, the true red of the garnets comes alive. In areas where the Garnet Gel (Coarse) was applied thinly, you can see the varying colors of the garnet: pink, brown and red. In deep, thick areas, the gel is a ruddy brown bordering on black.

detail of the surface

In this closeup you can see that the small beads of garnet vary in color. The color of the beads is also affected by the green and pink of the ground.

gallery of gel applications

highly textured surfaces

Artists Merle Rosen and Jean Luc Toledo each use gels to create gritty, interesting surfaces. For *Red Woman*, Rosen used Coarse Pumice Gel to create a textured surface over which she applied oil pastels. In *Green Man*, she scraped back Coarse Alumina to reveal a Pyrrole Red ground over which she applied fluid acrylics. Toledo used Coarse Pumice Gel to lend a rawness that enhances the gestural quality of the drawing.

Red Woman (top right)
Merle Rosen
Mixed media on board
7" × 5" (18cm × 13cm)

Green Man (bottom right)
Merle Rosen
Acrylic on board
7" × 5" (18cm × 13cm)

Untitled (bottom left)
Jean Luc Toledo
Acrylic on paper
9" × 7½" (23cm × 19cm)

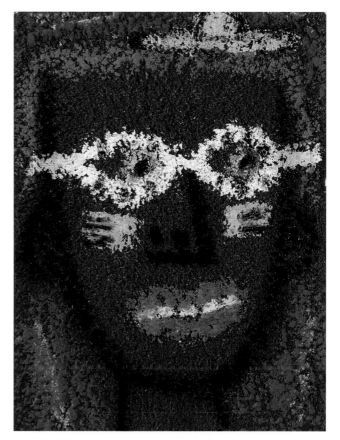

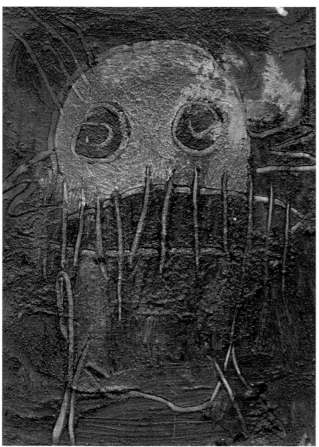

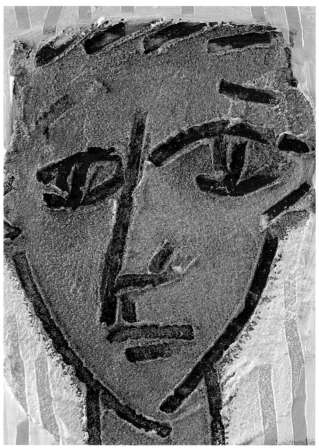

molded acrylic objects

Here's an entirely different way to change the surface of your canvas: make three-dimensional objects with a gel. The new silicone baking dishes are great to use with acrylic; they easily release the acrylic and easily clean up.

The gels also make great adhesives for gluing objects to canvas. I have seen leaves, fabrics, rags, marbles, pieces of wood, straws and broken ceramics glued to different supports.

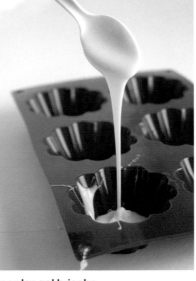

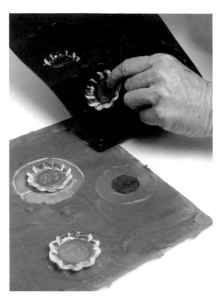

clear tar gel brioche
Use a spoon to pour Clear Tar Gel into a silicone brioche pan. Build up the object's thickness by pouring shallow layers and allowing each layer to dry thoroughly. If you pour thickly, you might have to wait a few weeks for the acrylic to dry. You can also pour thin layers of separate colors, creating a strata of pigments.

removing brioche shapes
Acrylic won't stick to the silicone, so the pieces easily pop out. The centers of the objects will be somewhat hollow due to the shrinkage of the acrylic as it dries. You can paint these molded pieces or use their translucency to let the color underneath show through.

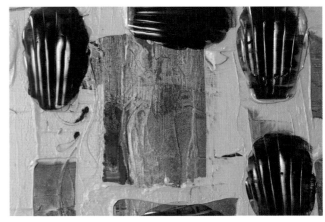

attach the objects with soft gel (gloss)
Attach the transparent shapes with Soft Gel (Gloss). The clear edges catch the light, creating a glass-like illusion.

a distinctive visual "treat"
Follow the same process using a silicone madeleine pan and Self Leveling Clear Gel. Drybrush over the shell shapes once they're glued to the surface with Soft Gel (Gloss). The ridged edges catch some of the brushstroke, leaving clear spaces where the eye can see deep into the shape.

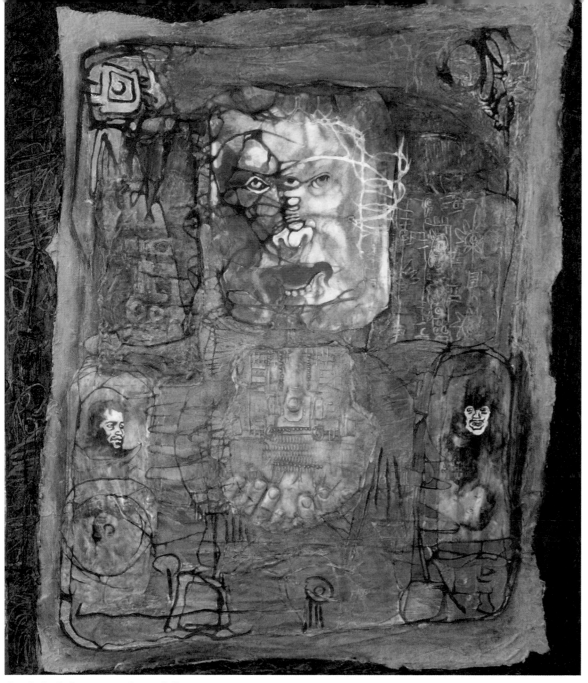

simple technique, complex painting

Taking the simple idea of creating impressions in acrylic, Jean Luc Toledo expanded it to produce complex paintings. This painting has several separate canvases glued (with gel) onto a large wooden panel. Images from engravings that have been photocopied and used as gel transfers (see chapter 6) also appear in the work. Poured lines were added with tinted Clear Tar Gel, and sgraffito effects were carved into wet gels.

Tot'aim
Jean Luc Toledo
Acrylic on wood panel
32½" × 27½" (83cm × 70cm)
Collection of the artist

detail
Jean Luc Toledo makes his own silicone molds from body parts and other objects. He uses Clear Tar Gel to create embossed acrylic fillets that are layered directly into his paintings. Some of the acrylic skins are from actual objects such as shells and fossils, and others are made from clay impressions.

wet-into-wet with paint and gels

When I think of a wet-into-wet technique, I think spontaneous and very loose—especially when talking about working wet acrylic paint into wet acrylic paint. Acrylics have a faster drying time than other mediums, and acrylic artists typically work very quickly when using a wet-into-wet technique.

Working with generous applications of acrylic will yield longer open times.

use thick applications for a longer open time
Here, Soft Gel (Gloss) was tinted with a gray mixture of Ultramarine Blue, Raw Umber and Titanium White, then painted over an abandoned surface. Notice how thick the application of acrylic is. This will take a long time to dry, but it will create lots of texture.

work directly into the wet surface
Load the brush with a fluid color and paint directly into the wet bed of Soft Gel (Gloss). Paint quickly and loosely, creating deep brush strokes, scraping back to the underpainting. As you move the brush through the Soft Gel mixture, you'll add wet color to the brush, creating new color mixtures.

detail of surface
In this closeup you can see how the Soft Gel (Gloss) mixture retains a squishy, subtle brushstroke. If you want crisper, more defined brushstrokes, use Heavy Gel (Matte) instead.

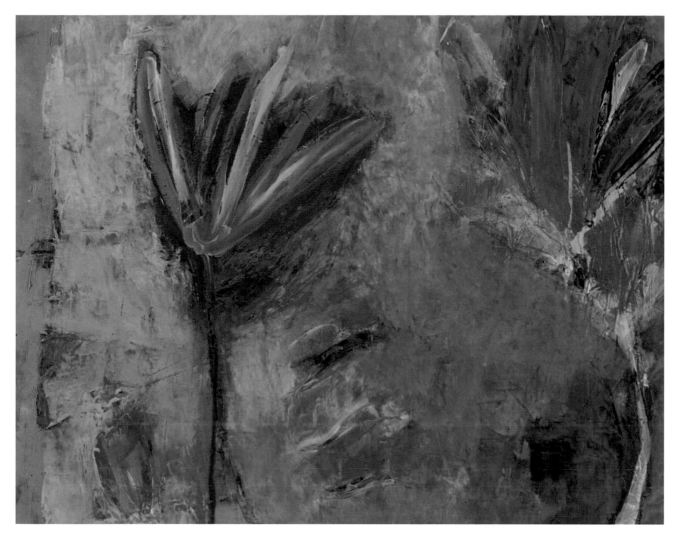

multiple layers of gels

Here artist Bonnie Cutts used mixtures of Heavy Gel (Matte) and fluid and heavy body paints. They were applied to the surface of the canvas in multiple layers while wet. The mixtures were laid down and then scraped back with large palette knives, a process that continuously mixed the colors and pulled them across the canvas. A brush was used for more detail on the top layers. Fluid Matte Medium was applied as a topcoat to even out the sheen.

Buds Appear
Bonnie Cutts
Acrylic on canvas
24" × 30" (61cm × 76cm)
Collection of the artist
Photograph by Ed Bock

K.D. Tobin

I like to work snippets of newspaper text and headlines from around the world into each painting. These pieces of newsprint act as time-coding elements to root the individual piece to the period in which it was created. This subtle process also contributes to the rich surface texture imparted into each work.

Artist K.D. Tobin in his studio

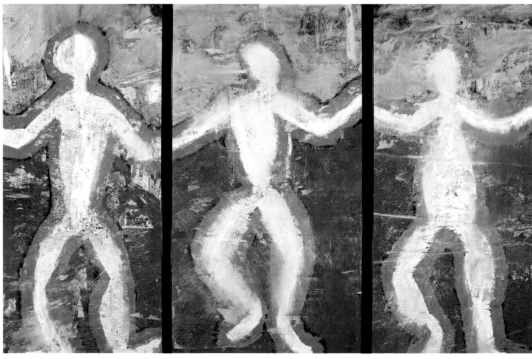

I generally like to limit a work to a few main colors for the background and a limited palette of opposing colors for the subject. I often return to the work at a later date and make adjustments with various accent colors.

Woman on a Windowsill
K.D. Tobin
Acrylic and mixed media on canvas
60½" × 60½" (154cm × 154cm)
Private collection

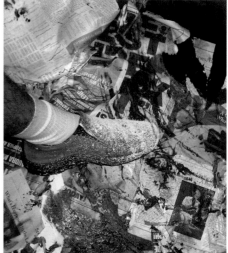

preparing the surface

I brush three layers of gesso over the canvas to create the necessary tooth for the newsprint and the other elements I'll work into and onto the canvas. I use a heavyweight cotton canvas because it must take a fair amount of abuse as I walk, crawl, scratch and scrape across its surface. After the gesso has dried, I create an abstract underpainting that will provide the mix of color that shows through after I've scraped off layers of paint and newsprint. I let this dry for a couple of hours, then sketch a rough image of the subject with willow charcoal sticks. These charcoal strokes are very broad, but they will soon disappear under an onslaught of acrylic and newsprint.

newsprint, paint and gel melding together

I mist the surface to cause the paper to disintegrate and allow the paint, gel and newsprint to mix and mingle together and become part of one surface. Once the surface has reached the proper moisture level, I scuff and scrape off the newsprint with rubber-soled shoes and a variety of other instruments.

excavating the figure

From here the piece's completion is a bit of a whirlwind. I selectively scrape off the newsprint with various metal-edged implements, then abrade the canvas with rough-textured rubber gloves and stiff-bristled brooms; even circular bristle brushes from an old floor polisher are brought to bear upon the surface. I scuff and kick across the surface with the rubber soles of my shoes and the paint gets trampled and ground under the weight of my hands and knees as I crawl across the surface. I add more paint, gel, water and newsprint as I see fit, while moving between this and other canvases I have in process. This is a full body workout, not a quiet contemplation. When I say I got into a painting, I *really* got into the painting.

subtractive
techniques

ALL PAINTINGS ARE SOMEWHAT ADDITIVE
and subtractive. The process of painting involves layering, adding opacities that obscure, and finding the confidence to cover over that perfect mark. In many ways, this is about letting go and trusting that you can pull the painting together in the end—that you have the skill to know when to stop, when to wait, when to look, and when to begin to bury again.

There are several technical ways an artist can subtract from a painting: cutting, carving, sanding, applying chemical additives to dry paint layers, or, while a layer is wet, an artist can excavate to reveal a substructure. In this chapter, I'll show three ways to subtract from acrylic films by engraving, taping and sanding. At the end, Ulysses Jackson's painting process proves you can literally carve out paint from a canvas.

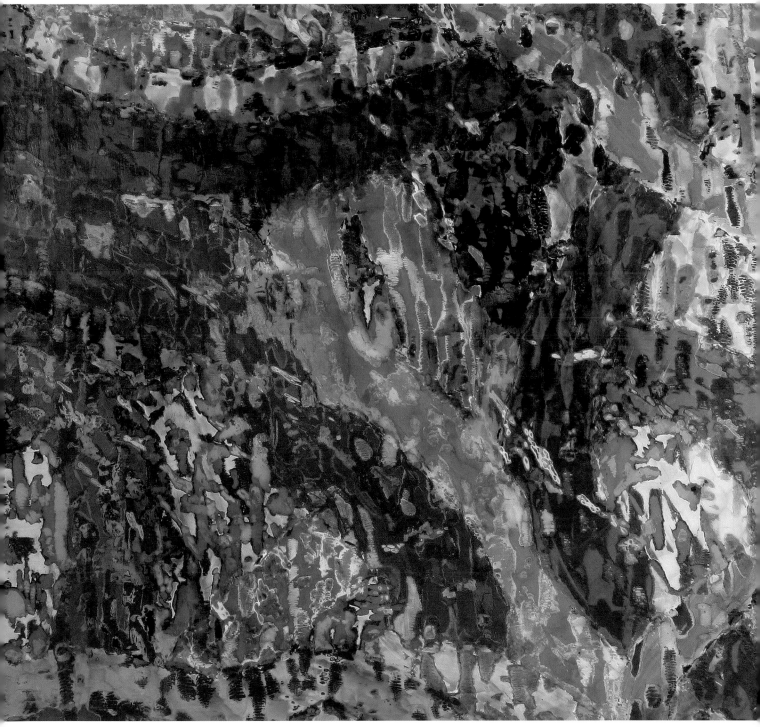

Water Garden (Detail)
Ulysses Jackson
Diptych, acrylic on canvas

engraving acrylic

Let's explore the act of etching on acrylic. I often use a rotary tool with an engraving attachment on Plexiglas to create etched plates for monoprinting. I realized I could apply this idea to dry acrylic gel, creating a burr that runs along an engraved line's edge that will capture paint. You need a rather hard surface for the rotary tool to engrave correctly. I use Coarse Molding Paste because it has a great texture for washes and is a harder gel than Light Molding Paste. Plus, I love the bright white blurred line that this achieves.

materials

FLUID ACRYLICS
Diarylide Yellow, Sap Green Hue, Titanium White, Turquois (Phthalo)

TOOLS
1-inch (25mm) synthetic flat brush, no. 8 synthetic filbert brush, palette knife, rotary tool

SURFACE
Rigid surface such as a wood panel

OTHER
Acrylic Glazing Liquid, Coarse Molding Paste

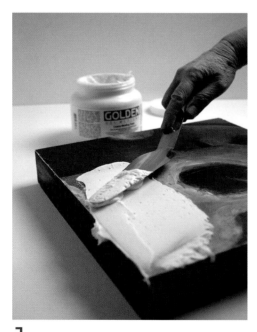

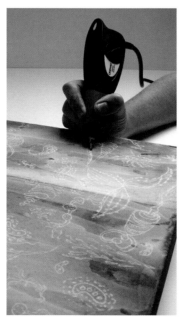

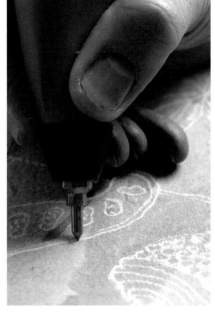

1 apply the coarse molding paste

Apply Coarse Molding Paste to the surface. I used an old painting on a wooden panel because it has a firm surface and an interesting abstract color pattern. Apply some of the Coarse Molding Paste thinly in some areas so the underpainting still shows through.

2 etch the surface

Use the rotary tool as a drawing implement. The rotary tool punches tiny holes into the acrylic surface. The holes will be more obvious at a slower setting. For a more continuous line, use a faster setting.

3 apply washes of paint

Brush clean water over the surface, then apply a wash of Fluid Sap Green Hue. The wash will sink into the grooves, creating a darker line.

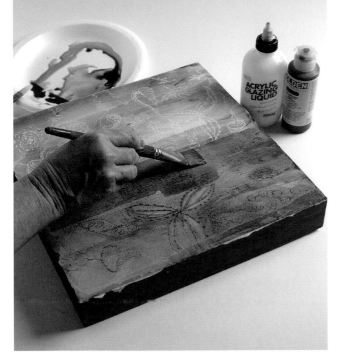

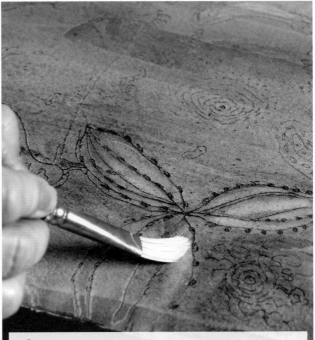

4 reclaim interesting areas

While the wash is still damp, dip a brush in Acrylic Glazing Liquid and use this to remove the wash from specific areas. Acrylic Glazing Liquid slows the drying time and adds a slippery feel to paint, easing its removal. Let this dry.

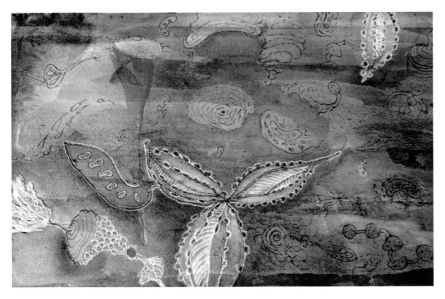

5 continue engraving and add more details

Use the rotary tool to break through the wash's surface. The bright white lines are where the rotary tool cut through to the layer of Coarse Molding Paste. You can add more detail, painting in other pigments. Notice the translucency of the Coarse Molding Paste allows you to still see some of the original underpainting.

rotary tool options

A rotary tool can engrave or decorate a wide variety of materials, including metal, plastic, wood and leather. Look for one that includes a soft-grip body, replaceable carbide engraving points and a variable stroke control so you can etch fine lines or deep grooves.

perfect hard edges

Many artists use tape to produce clean, hard edges. Here you'll deal with two issues you must work around when using tape with acrylic: the elasticity of acrylic paint and applying tape to an uneven surface.

Acrylic's elasticity is a fabulous benefit, but it can be a bit trying when you're attempting to remove tape from painted areas. If the paint film is too soft and elastic, it will pull up with the tape during removal. You can get around this by mixing acrylic colors with GAC 200 to harden the paint's film.

Tape or masking fluid applied to a flat surface adheres firmly and produces a clean edge, but if you're working on a textured surface, the tape will not lie completely flat. Any paint applied over the tape on such a surface will seep under the edges, unless you use GAC 500 to seal them.

materials

FLUID ACRYLICS
Cobalt Teal, Titan Buff

HEAVY BODY ACRYLICS
Cobalt Titanate Green

TOOLS
1-inch (25mm) synthetic flat brush, low-tack tape (such as automotive or painting tape)

SURFACE
Any surface

OTHER
Craft knife, GAC 200, GAC 500

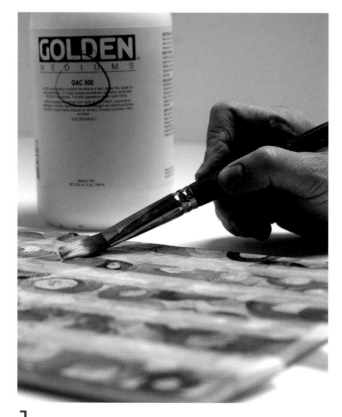

1 tape the surface and apply gac 500
Apply rows of masking tape to the surface in anticipation of painting stripes. Brush GAC 500 over the taped edges to seal them. Let this dry.

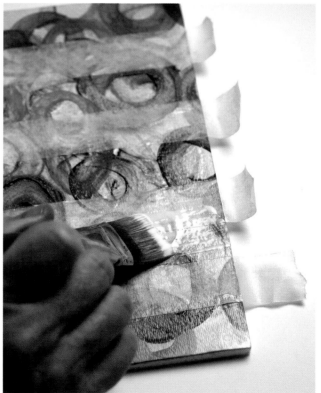

2 apply more coats of gac 500
Check to see whether you need another coat. It took me three coats to make sure that the small crevices under the tape were filled.

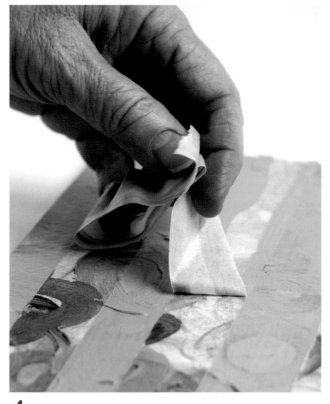

3 paint the stripes

When the layers of GAC 500 are dry, paint on the stripes. Add 1 part GAC 200 to 2 parts paint mixture. GAC 200 acts as a hardener and thins down the paint mixture for a less obvious brushstroke.

4 carefully remove the tape

Remove the tape slowly. Keep a craft knife handy for the small, stubborn areas that are difficult to remove.

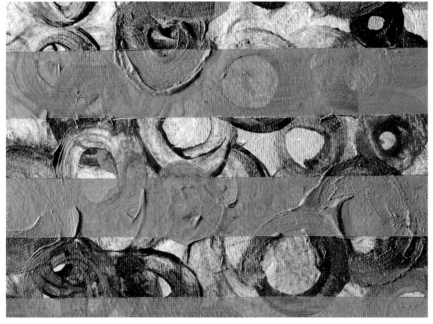

well-defined edges

Hard-edge painting was popular in the late 1950s when the quick-drying attributes of acrylic were sought after, allowing the artist to build layer upon layer of clean, sharply defined shapes. Airbrush artists have exploited this sharp edge to its fullest extent, using precut stencils, hand-cut shapes, and liquid and paper masks to define areas.

know your gac

GAC 500 is a liquid acrylic polymer that has good leveling ability and forms a glossy film. It's the hardest polymer that is suitable for flexible supports. Use it to increase the hardness of a paint film and reduce tack while maintaining flexibility.

GAC 200 is best for nonflexible surfaces that are being taped. Blending GAC 200 with paint that will be applied over the tape cuts down on elasticity and creates cleaner edges. It also reduces the tack of a dry acrylic paint film. (When adding GAC 200 to paint for flexible supports, use a maximum of 1 part GAC 200 to 2 parts paint.)

simple technique, intricate pattern

Using this rather simple taping technique, Paul Yanko creates intricate, complex and exquisite paintings. Paul tapes each edge, using combinations of gels and paints. The geometric shapes have varying degrees of translucency and their surfaces vary from matte to satin, as do the thickness of the applications.

DartArrowDart
Paul Yanko
Acrylic on canvas
24" × 24" (61cm × 61cm)
Contemporary Carolina Collection, Ashley River Tower, Charleston, South Carolina

sanding back the acrylic surface

When working subractively in acrylic, it's helpful to understand that acrylic is a thermoplastic material that softens when heated. Vigorously rubbing acrylic with sandpaper will create heat, soften the acrylic and quickly gum up the sandpaper.

Hard Molding Paste was developed to allow artists to sand an acrylic surface. It has more solids in proportion to acrylic binder, so it dries to a hard surface. It's also hard enough for carving.

This process is about creating alternating layers of tinted Hard Molding Paste, then sanding back through these layers. I limited the palette to three colors.

A rigid substrate is necessary for the weight of the many layers and for the physical sanding of the surface. Hard Molding Paste does not hold peaks like some of the other gels, so its viscosity is well suited for keeping the surface smooth.

materials

FLUID ACRYLICS
Carbon Black

HEAVY BODY ACRYLICS
Cobalt Titanate Green

TOOLS
Dust mask, electric hand sander, palette knife, plastic stencils, safety goggles

SURFACE
Rigid substrate, such as a wood panel

OTHER
Hard Molding Paste

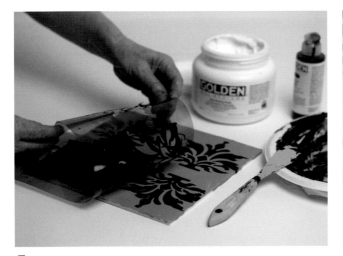

1 prepare the surface and apply stencils

Mix 7 parts Hard Molding Paste with 3 parts Cobalt Titanate Green. Use the palette knife to apply it and smooth out the surface. Let this dry.

Tape a stencil to the surface. Mix 5 parts Carbon Black with 5 parts Hard Molding Paste. Spread this over the stencil with a palette knife to about ¼-inch (6mm) thickness, then slowly pull up the stencil.

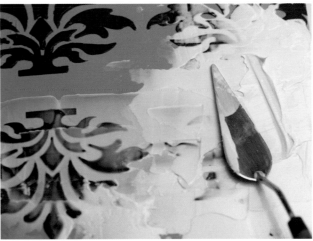

2 apply more hard molding paste

Fill in the surface around and over the black stencil with untinted Hard Molding Paste, creating a flat, even surface for the next stencil layer. When the spaces are filled around each stencil, continue adding more of the untinted Hard Molding Paste, covering the entire surface until it is white and fairly smooth. Let this dry.

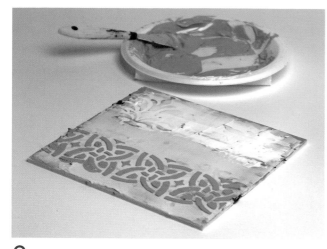

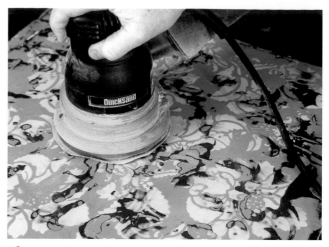

3 build layers with additional stencils and different colors

Switch to a different stencil pattern for an additional layer and change the color to Cobalt Titanate Green. Let this dry, then fill in the green pattern with the Carbon Black mixture, creating a flat black layer, and allow it to dry. Add another stencil layer with untinted Hard Molding Paste. When that's dry, apply a top layer of the Carbon Black mixture and let dry.

4 sand back layers

Using an electric hand sander, sand back to reveal the different patterns. Since I don't have the right ventilation system in my studio for this type of sanding, I have to work outside. I always wear a mask and goggles.

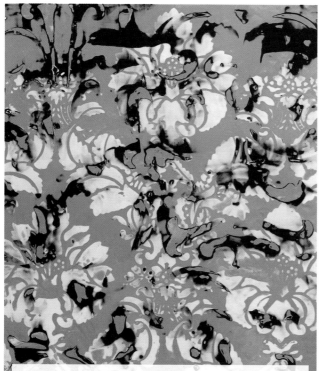

excavating layers
Sanding reveals cross sections of layers. The electric hand sander creates a beautiful, smooth, almost glass-like surface. In this piece, my first layer was a yellow, which pokes through in areas where I sanded back very deeply.

drying time

Acrylics quickly dry to the touch, but take much longer to fully cure—sometimes up to a year. The longer acrylic dries, the easier it is to sand. Each layer in this demo dried for two to three days. If the bottom layers aren't dry and you keep adding thickness, the entire piece will take even longer to set up for the sanding.

proper ventilation is a must

When sanding any material, the pigments become airborne, so it's essential to use adequate ventilation and wear the appropriate NIOSH-approved mask for the materials you sand. Safety goggles are also recommended. Never sand cadmiums. Always read the labels and do your research.

Ulysses Jackson

As an artist, I'm constantly looking at forms, negative spaces and details, cataloging the world around me. My position in Golden's Research and Development Lab, where I look at paint every day, has trained my eye to understand the smallest differences in color. Walls most people would see as white I can break down into thousands of colors. My in-depth knowledge of how paint is made and how its properties can be modified to suit my specific needs has given me an understanding that allows me to bring a range of textural and visual aspects to my work. Many exotic materials find their way into the paint in my studio, such as rare pigments that are hand-dispersed with a glass muller.

By the time I'm ready to start painting, I usually have a few ideas of colors that interest me. These colors arise from everything I come in contact with; a Vermeer painting, someone's green shirt reflecting color onto their skin, my tea while steeping, or a color match for an unrelated project could spark another direction.

Artist Ulysses Jackson seated in front of *Water Garden*

Most of my color combinations involve four to five heavy body colors in varying amounts. I use lots of mediums and gels for transparency and sheen modifications, as well as interference colors for refractive depth.

Water Garden
Ulysses Jackson
Diptych, acrylic on canvas
78" × 72" (198cm × 183cm)

There's something delightful in executing an idea perfectly, but it takes a long time for me to complete a painting. I can cover a 36" × 24" (91cm × 61cm) canvas with forms in a six-hour session, but larger canvases may take several days. These forms may remain discreet, with edges defining color relationships much like plots in a field, or soft gradients may appear like a setting sun. The drying time varies, but the average is usually forty-eight hours, during which time I work on another painting or I study the image as it dries. The color relationships are never perfect and there are usually areas of texture that need to be modified, which leads to additional forms that emerge as corrections are made.

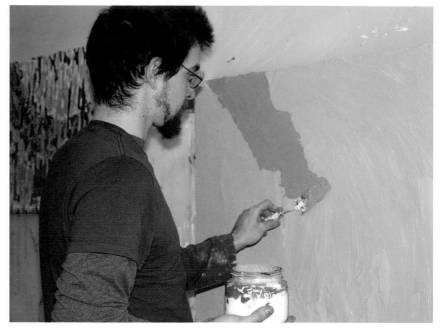

applying color mixtures

The first step is getting away from the canvas texture. I don't like the canvas's manufactured texture showing, and my techniques are so aggressive that I need the buffer of paint for protection. I usually cover the canvas completely with ten to twelve coats of flat color. The colors are applied with a large, ¼-inch (6mm) thick custom-made tool that's similar to a palette knife.

side view of paint layers

Here you can see the multiple layers of color. These are the raw beginnings of my painting process.

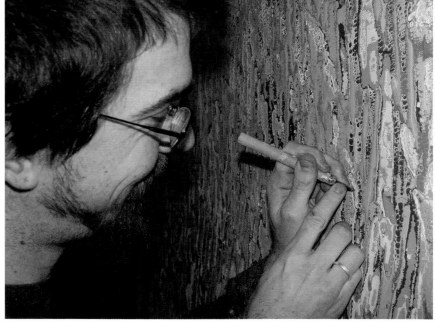

excavating paint with a woodcutting tool

As the image develops, I resurface sections of color and form now hidden deep in the composition. I feel like a surgeon operating on a very delicate patient; any slip could lead to a hole, destroying many weeks of work. I use many tools, each creating a specific mark, with each mark adding to the appearance of an "effortless" gestural effect. I'll remove one to three small paint layers at a time and may repeat this process many thousands of times, continually adding new forms.

adding color and form over excised areas

As forms are developing, I often use a mixture of 5 parts Regular Gel (Gloss) to 1 part Acrylic Glazing Liquid as a separation coat to minimize texture and create depth. I also apply glazes throughout the process. Depending on the effect I want to achieve, I use various mediums or water, all of which are mixed with colors in varying amounts. Over the course of creating a painting, I'll apply thirty to forty glazes with a bristle brush, creating an optical luminosity unachievable with color alone.

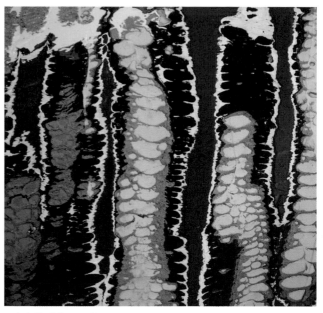
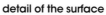

detail of the surface

Subtle composition is one of the key elements in my work. This gives viewers the impression that the painting changes every time they look at it, even though all of the information is included from the start.

the final stages

There's a wall in my studio devoted to analyzing the last painting I completed. After about a month, there's usually a point when I find myself studying a painting and feeling there's nothing to add or remove.

At that point, I sign and title the back with a stain made from Heavy Body Carbon Black thinned to a watery consistency. I paint the sides of the canvas with medium gray to finish the edges and give the painting added weight. My painting technique builds up such a surface that paint extends over the edges, making framing impossible—but a frame would detract from the overall effect anyway.

collage & acrylic skins

ONE OF THE BENEFITS OF ACRYLIC IS THAT IT forms a continuous, flexible film. It sounds so boring, but acrylic's amazing ability to form a flexible film is unique to the medium and allows artists to take that film off a support and into the world of three dimensions. When acrylic is painted or poured onto a surface that it won't adhere to, it then can be peeled off and used as a collage element in a painting or as a sculptural element. You could completely abandon canvas and stretcher bars by simply building your painting on a sheet of glass, and, when it's dry, pulling it up. Artists have found unique hanging solutions for these skins: rods, pushpins, rivets—even clothespins. Some artists have embedded metal skins or plastic mesh for added strength. You can make very thin and delicate skins, or thick, dense, felt-like pieces.

The skins can be cut, twisted, layered, woven and glued to a multitude of surfaces. Almost any acrylic gel or paint will make a skin because they all form a film and remain flexible.

Self Portrait (Detail)
Phillip Garrett
Acrylic on paper over board

acrylic skins as collage elements

The key to making an acrylic skin is to use a surface that acrylic won't stick to. There are a variety of surfaces that you can use. My favorite is a large piece of high density polyethylene (HDPE), which can be found at a plastic distributor. HDPE sheets come in different thicknesses and you can have them cut to the size you need. HDPE is lightweight, rigid and easily cleaned by scraping the acrylic off with a putty knife. Other surface options include sheets of glass, garbage bags, freezer paper, silicone baking sheets and plastic sheeting from the hardware store.

making acrylic skins

Any acrylic product will make a skin, though not all are recommended. OPEN acrylics, Absorbent Ground, Crackle Paste and varnishes are not recommended for creating skins. After you've chosen the surface, paint, pour, drip or squeegee fluid or heavy body acrylics or gels onto the surface and let dry. Test the skin's sturdiness by loosening an edge with your fingernail or a putty knife, then carefully peel up the skin. Do not let the skin fold back onto itself, as it may stick together.

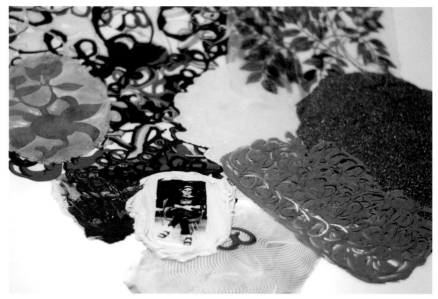

a collection of acrylic skins
These skins are made from various acrylic gels and paints, including poured fluid acrylics, Glass Bead Gel, Fiber Paste, Pearl Mica mixed with Coarse Molding Paste, Clear Tar Gel and Molding Paste. Several of the skins have image transfers applied (see chapter 6). Keep a collection of skins on hand to use as collage elements in your artwork.

poured acrylic shapes
This example shows how skins can be used playfully to create a graphic element. Simply pour a single fluid acrylic color onto a sheet of HDPE, moving the bottle around to create different shapes. Once these pours have dried fully, you can easily peel them up and move them around on the gessoed surface until you're ready to secure them with Soft Gel (Matte).

the drying process

Acrylic can take a year to fully coalesce, but it becomes less tacky the longer it has to dry.

acrylic skin collage

Create the skins for this collage ahead of time by painting them with a large brush on a piece of HDPE. For contrast, create shiny skins with GAC 500 and matte skins with Heavy Gel (Matte). Mix several different combinations of colors to mix with the GAC 500 and the Heavy Gel (Matte) for skins that vary in surface reflection. Using thick gels like these leaves behind a distinctive brushstroke.

materials

FLUID ACRYLICS
Anthraquinone Blue, Chromium Oxide Green, Cobalt Blue, Cobalt Teal

TOOLS
3-inch (76mm) wide housepainting brush, craft knife, putty knife, T-square, wax paper

SURFACE
HDPE sheet ½-inch (13 mm) thick, wood panel

OTHER
GAC 500, Heavy Gel (Matte), Soft Gel (Matte)

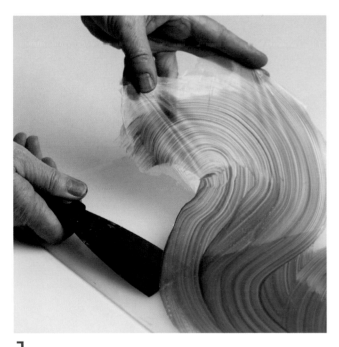

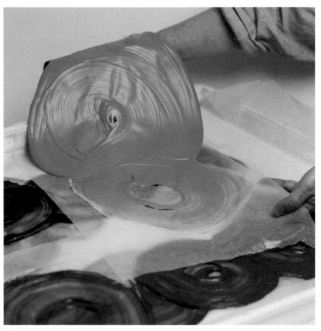

1 remove the skin from the hdpe

Use a putty knife to remove the skin from the HDPE. The ends of the paint swirls are very thin and delicate, so be careful as you handle them. This glossy skin was made by mixing GAC 500 with Fluid Chromium Oxide Green.

2 let the skins dry thoroughly

Layer wax paper between the different skins to let them completely dry. When newly dry, acrylic can still be tacky, and the skins will stick together if you aren't careful. For this more opaque blue skin I mixed Heavy Gel (Matte) with some opaque pigments for a less transparent look.

3 position the skins on the new surface

Position the skins on the collage surface. Since they're dry, you can pick up the skins and move them around, playing with different visual possibilities. Overlap the skins or match them up with other skins, and use a craft knife or T-square to cut them. Once you've established a design you like, glue the skins to the surface with Soft Gel (Matte).

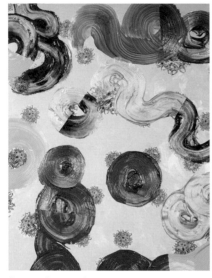

the next move is yours

Here, I used the various skins as puzzle pieces, making decisions with transparencies and opacities, and using the background images to create a mysterious play with the brushstrokes on the acrylic skins.

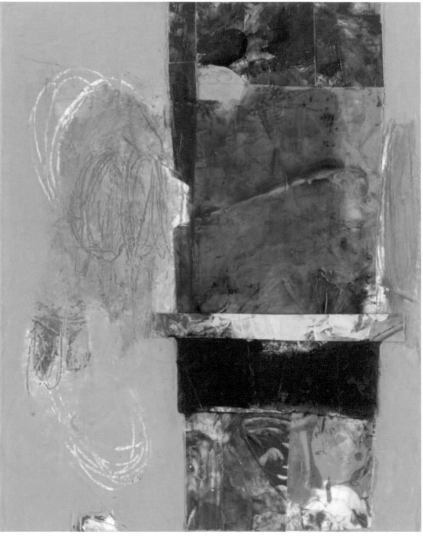

acrylic (and paper) collage

Artist Bonnie Cutts glues acrylic skins and paper with gel to compose her painting.

Untitled
Bonnie Cutts
Acrylic and paper on canvas
10" × 8" (25cm × 20cm)

handmade "paper" skins

Fiber Paste is a gel filled with synthetic fibers that looks like wet paper pulp in the jar. The gel dries to a paperlike surface with all the fabulous attributes of acrylic: it's not resoluble, it's flexible, and you can use it to make an acrylic skin. This means you can make any shape you want that mimics handmade paper.

customize shapes with fiber paste
Use a palette knife to shape the Fiber Paste as you spread it over a piece of HDPE, glass or freezer paper. You can create a deckled edge with your fingers to enhance the handmade appearance. Let the Fiber Paste dry overnight or longer, then slide a flat scraper or palette knife under the edges to release it from the surface.

fiber paste is flexible
An acrylic Fiber Paste skin is as flexible as a piece of paper. The dry surface is much like handmade paper with a rough surface. If you want a less-textured surface, while the skin is still wet, use a wet brush to carefully smooth out some of the texture. Like paper, a Fiber Paste skin can be torn, rolled and cut with scissors, but it will not disintegrate like paper.

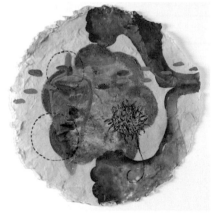

simulating watercolor on paper
The final piece has the quality of a watercolor painting done on handmade paper. I painted the surface with a light coat of Naples Yellow Hue and the large flower shape with a thin layer of Interference Red Oxide. The maple seed was painted in with a thin wash of Quinacridone/Nickel Azo Gold. The cone shape is a mixture of Cobalt Teal and Cerulean Blue Deep. The floating ovals are Green Gold and Chromium Oxide Green. Naphthol Red Medium was used for the dotted line, and the seed ball from a sweet gum tree was painted with Ultramarine Blue.

examples of acrylic skins

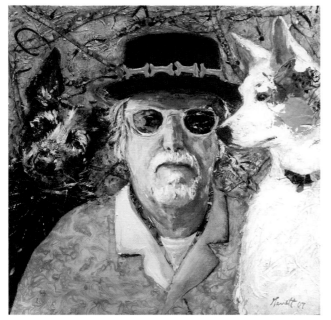

acrylic skins as an integral part of a painting

Artist Phil Garrett used marbled skins throughout this piece. Several layers of skins were used to develop the background. They were also used in the shirt and for the bones on the porkpie hat. One large skin creates a shadow area on the face of the dog in the foreground.

Mando Dog and the Heeler Sisters
Phillip Garrett
Acrylic on linen
24" × 24" (61cm × 61cm)

creative approach to acrylic skins

Here Miles Laventhall has taken acrylic skins embedded with Garnet Gel (Coarse) and used them sculpturally. They bring to mind spider webs, flood residues and ghostly images.

Wind and Willow (Detail)
Miles Laventhall
Curly willow, gold leaf, acrylic and transfers
76" × 45" × 20" (193cm × 114cm × 51cm)

Phil Garrett

My approach to painting is influenced by the work of several of my artistic heroes, most of whose work I encountered while I was a student in the San Francisco Bay area in the 1970s: artists like William T. Wiley, Roy Dean De Forest and Wayne Thiebaud, and earlier figure painters such as Elmer Bischoff, Nathan Oliveira and David Park. Expressionist paint handling and the intense color and funky humor that are characteristic of these painters are things that I strive for in my own painting.

Artist Phil Garrett in his South Carolina studio

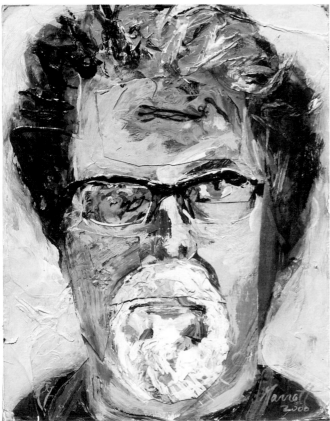

This painting utilizes a unique acrylic paint technique to create visual interest and a fresh surface. I start by prepping the support for the painting. I like the texture of artist's linen in my work, but I need a sturdy support for the skins and the thicker paint applications, so my support consists of linen "glued" with a thin, even layer of Soft Gel (Gloss) and stretched over a sealed panel attached to stretcher bars. I then apply two coats each of GAC 100 and gesso, letting each coat dry before applying the next layer.

Self Portrait
Phillip Garrett
Acrylic on paper over board
16" × 12" (41cm × 30cm)

I made the large skins by pouring Clear Tar Gel on HDPE, then dripping Matte fluids and fluid acrylics on the surface. I then dragged the point of a palette knife through the wet paint for a marbleized look and let the skins dry for several days.

While the large skins dried, I worked on the smaller skins, such as pours in the shape of my glasses. I did several of these in case some tore or were damaged in the process of peeling them off the HDPE.

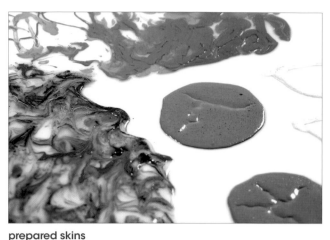

prepared skins
Here you can see a selection of the large acrylic skins I prepared ahead of time.

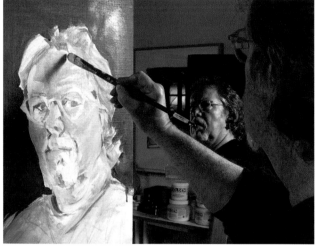

developing the portrait
I set up two easels for working on the painting, one for my support and the other for the mirror. First I sketched in the head and shoulders with a soft graphite stick, concentrating on getting the rough landmarks and proportions down. Then I did an underpainting of Heavy Body Cobalt Titanate Green, Cobalt Green and Titanium White, to establish the tonal values and the planes of the face and shadows. While this dried, I laid in a background color with a paint pad. While this dried, I returned to the face, building colors with a relatively simple palette.

preparing skins for the portrait
When I'm satisfied with the portrait, I start adding skins. I used the marbled paint skin for the lenses, which I easily cut with scissors.

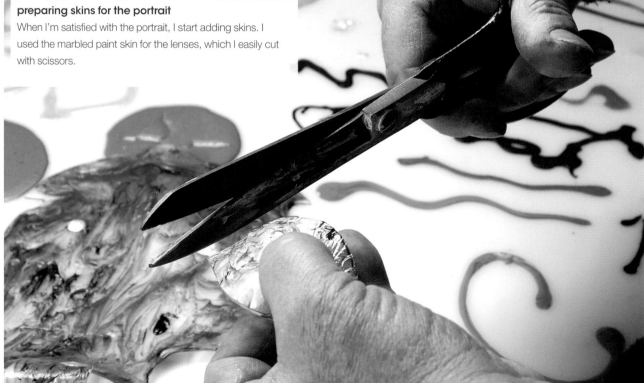

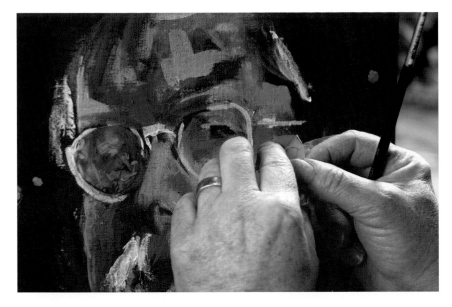

gluing the skins onto the surface

Here I'm gluing the lenses with Soft Gel (Gloss), which I use to adhere all the skins to the surface.

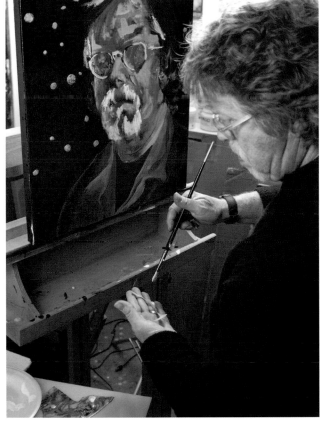

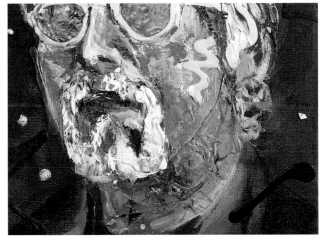

the final layers

At this juncture, there were many layers and numerous glazes, and some passages had become thick and highly textured. In some areas, I did a lot of scrubbing back with alcohol; in others I added thicker paint applications with heavy body acrylics thickened with Extra Heavy Gel (Matte). Sometimes I completely obliterated the skins with paint. I continued to cut and paste other skin fragments and added paint marks on the surface.

adding more skins and building glazes

Once I had added a series of smaller skins, I began to build up thicker layers. I added paints thickened with gel and applied with a palette knife and brush, and glued on several large slabs of skins. When the glasses were finished, I added a dark glaze over the top of the background using a mixture of Fluid Ultramarine Blue, a small amount of Fluid Raw Umber and GAC 100. The GAC 100 dried relatively quickly so I could work over it right away.

acrylic transfers
& the printed
image

WE ARE AWASH IN IMAGES, AND THE ADVANCEMENTS

in computers, scanners and copiers have had an enormous impact on

artists. In this chapter we'll look at melding the versatility of the acrylic

medium with several techniques of image reproduction.

In this chapter we'll explore the printed image with ink-jet printers (which

involves printing an image directly onto an acrylic skin) and the laser

(printed) transferred image (which involves transferring carbon-based ink

from a laser printer to an acrylic skin). It's important to know that you can

print on acrylic with ink-jet printers, but you cannot print on acrylic with

laser printers.

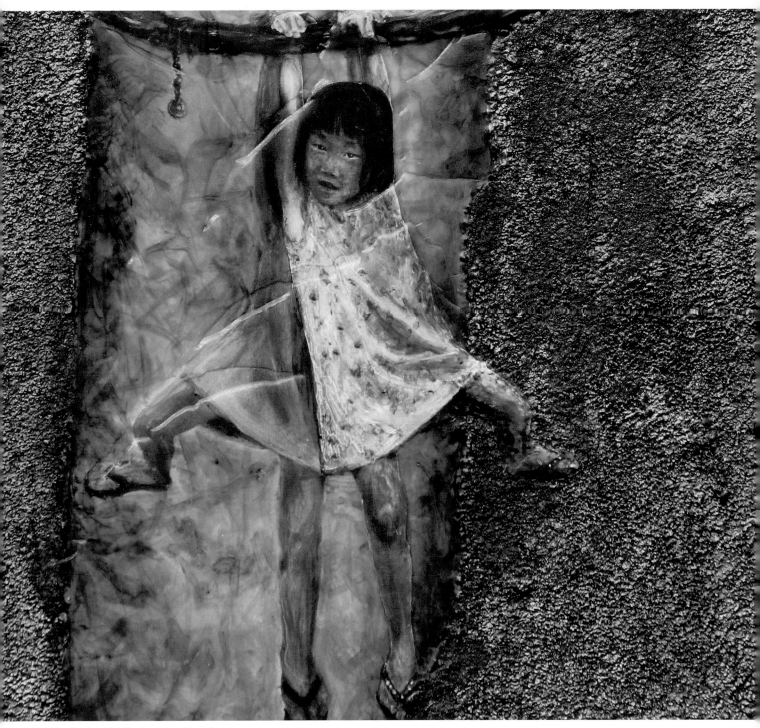

Hanging Under a Sagittarius Moon (Detail)
Corrine Loomis-Dietz
Acrylic on canvas

digital grounds for ink-jet printers

We're all familiar with printing with ink-jet printers on paper, but let's continue to push the boundaries of acrylic and replace that paper with an acrylic skin. The surface of an acrylic skin depends on which paint or gel you use, and to print on an acrylic skin with an ink-jet printer you need a skin with a porous surface that will allow the printer ink to adhere. Though there are some gels that will work for this, digital grounds provide the best surfaces, resulting in a crisp image. Besides paper, digital grounds can be applied to many surfaces that act as a *carrier sheet*, which allows the skin to be passed through the ink-jet printer. Other carrier sheet options include aluminum foil, metallic papers, wood veneers, and, with the right ink-jet printer, Plexiglas.

types of digital grounds

··· **Digital Ground White (Matte)** is a porous, opaque, white ground that can be used on a multitude of sur-faces and dries quickly.

··· **Digital Ground Clear (Gloss)** is a clear ground with a gloss sheen for use on most absorbent surfaces. It dries clear, allowing the underlying material to show through.

··· **Digital Ground for Non-Porous Surfaces** is similar to Digital Ground Clear, but has been altered so it can adhere to non-porous surfaces such as aluminum and plastic.

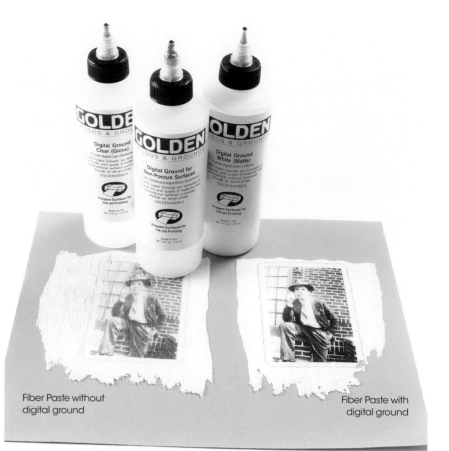

Fiber Paste without digital ground

Fiber Paste with digital ground

printing on acrylic skins, not paper

Fiber Paste skins will accept the ink from an ink-jet printer, but without a digital ground, much of the detail and crispness is lost. I applied Digital Ground White (Matte) over a Fiber Paste skin, which created excellent detail from the original photograph.

a word of caution

Damage to your printer is always a possibility when work-ing with any digital ground, especially as you push the boundaries of this new medium. Consider experimenting with digital grounds using older printers that might have less value to you and are out of warranty. If your printer is not out of warranty, modifying your printer in any way, or using materials not approved by the manufacturer, will usually void that coverage.

acrylic skin with ink-jet print

Here I'm using a digital image of one of my monoprints that I will print onto an acrylic skin of Fluid Silver (Fine) (fluid acrylics tend to work best for this technique). The paint's surface is glossy when dry. Because of its slick glossy surface, Digital Ground for Non-Porous Surfaces is the best way to add some tooth to the acrylic skin. Without this ground, the printer ink will not adhere to the skin's surface.

materials

FLUID ACRYLICS
Iridescent Silver (Fine)

TOOLS
Artist's tape, foam sponge brush, ink-jet printer, squeegee

SURFACE
Carrier sheet (here copy paper in plain white), HDPE sheet

OTHER
Digital Ground for Non-Porous Surfaces

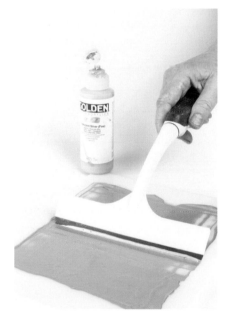

1 create the acrylic skin
Using a squeegee, spread Iridescent Silver (Fine) over a piece of HDPE on a level surface. Spread the acrylic paint to a thickness of 1/32-inch to 1/16-inch (1mm–2mm). Let the skin dry.

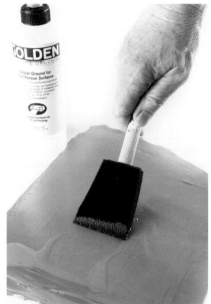

2 apply the digital ground
Apply the first coat of the Digital Ground for Non-Porous Surfaces with a foam brush and let dry. Then add one more coat, applying in a different direction. This ground is resoluble, so don't over-work the second coat.

3 print the skin
Tape the Iridescent Silver (Fine) skin to a plain piece of copy paper, so the printer will "read" it as paper and pull it through the printer. Use a tape that's easy to remove, such as artist's tape. Tape the leading edge and one side of the skin. Let the skin and the paper run through the printer.

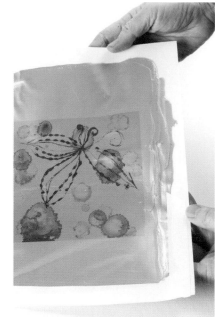

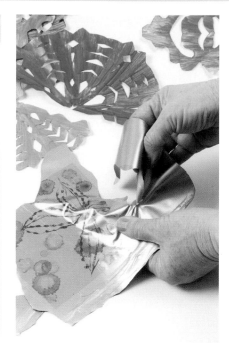

An exciting aspect of skins made with digital images is the ability to reuse your paintings and prints in a series. Familiar images can be repeated, and, thanks to the skin's flexibility, these images can be changed and revised.

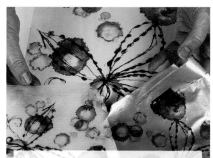

4 peel off the acrylic skin

Let the ink dry thoroughly. Separate the skin from the carrier sheet by peeling off the tape and lifting it from the paper.

5 assemble the elements

You can create additional acrylic skins with your ink-jet printer. You can tear the digital transfers for a ragged, varied edge, or cut with scissors for a defined edge.

different printed skins
The skin on the left is made with Acrylic Ground for Pastels and coated with Digital Ground Clear (Gloss). The image in the middle is the original monotype print. On the right is the Iridescent Silver skin.

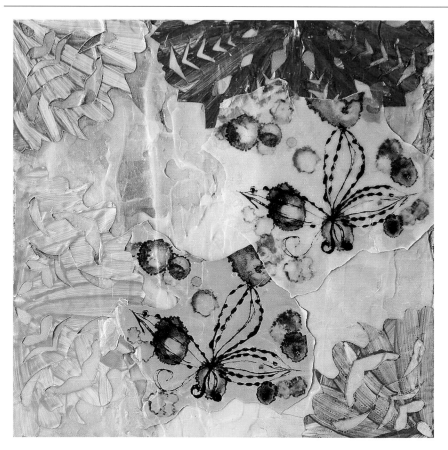

you decide the next step

There are several ways you can continue to work with the acrylic skins. You can paint over them, or, if you created a transparent skin, you can paint the back. You can even draw over them. Your choices are only limited by your imagination and willingness to test it.

sealing digital grounds

To seal the surface of the printed ground, spray ink-jet prints with two coats of an archival spray varnish (see chapter 12). This will allow you to paint over the image without it lifting up and it provides UVL protection.

applying a gel topcoat

Most ink-jet inks are water sensitive and may fade if exposed to ultraviolet light. Unless you plan to frame your work behind glass, you need some form of final protection.

The very best protection for any acrylic artwork is varnishing with a removable, professional-grade varnish (see chapter 12). Another option for a thicker application is to use a Gel Topcoat with UVLS, which will provide protection and reduce water sensitivity. Before applying a Gel Topcoat, seal the surface with several layers of a solvent-based archival spray varnish. Varnish is available in aerosol cans in gloss, matte and satin finishes.

Gel Topcoats with UVLS (ultraviolet light stabilizers) protection are available with a gloss or semigloss finish. Both will retain your brushstrokes while the ultraviolet light stabilizers prevent the inks and paints from fading. Gel Topcoats have a water-based formula that's easy to clean up. Always, without exception, test the Gel Topcoat on the same materials used for your artwork to confirm that the colors won't blur or lift.

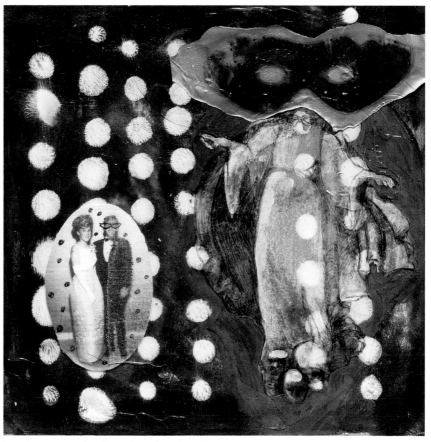

keeping your mixed-media artwork safe

I chose to use a Gel Topcoat on this collage because of the lightfastness issues of the combined materials. For instance, I used a blue ballpoint pen (not an archival choice for art making) for drawing and two ink-jet prints. I also wanted to add some clear texture to the surface. The pink mask was printed on a skin of Iridescent Silver, primed with Digital Ground Clear (Gloss), and torn to shape. The 1963 prom photo was printed on canvas primed with Digital Ground White (Matte) and cut into the oval shape with scissors.

do your research

There's a wealth of technical information on using digital grounds, the lightfastness of ink-jet prints, printers, setting up your printer, paths through the printer, airfade and safety issues available on the Internet. It's important to research all your alternatives before you send any acrylic skins through your printer.

basic laser image transfer

OK, so you don't want to risk damaging your ink-jet printer, but you still want to play with printing images on acrylic. There's a low-tech process for transferring laser-printed images to an acrylic skin.

The following demonstration combines three elements: an acrylic skin with a transferred photocopy image, a poured acrylic skin and a painted substrate combined to create a completely acrylic collage, no paper involved.

materials

FLUID ACRYLICS
Diarylide Yellow, Pyrrole Red

TOOLS
Photocopied (laser-printed) image on copier paper, plastic palette knife, plastic tub filled with clean water, scissors, small synthetic round, sponge or cotton rags

SURFACE
Prestretched canvas

OTHER
Clear Tar Gel, Soft Gel (Matte)

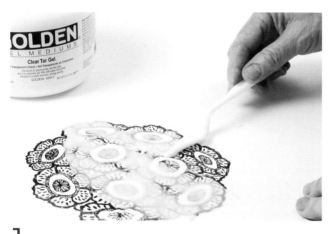

1 apply the clear tar gel
Apply Clear Tar Gel over an image that's been photocopied (laser) on copier paper. (I began with an image I had drawn with pencil, then photocopied.) Let this dry.

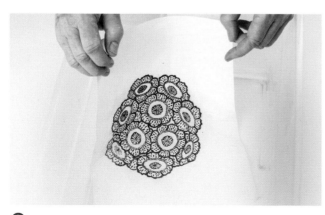

2 submerge the paper
Submerge the piece of paper in clean water and let it soak for a few minutes.

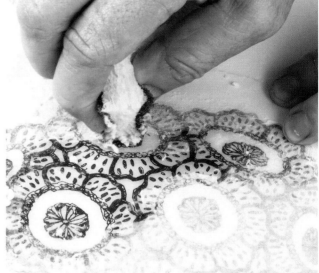

3 remove the paper
Take the image out of the water, placing the gel side face down. Use a sponge to gently rub the paper away. Start with the rough side of a kitchen sponge, then switch to the sponge's softer side and continue rubbing until the black lines are very clear. (A cotton rag also works well for this.)

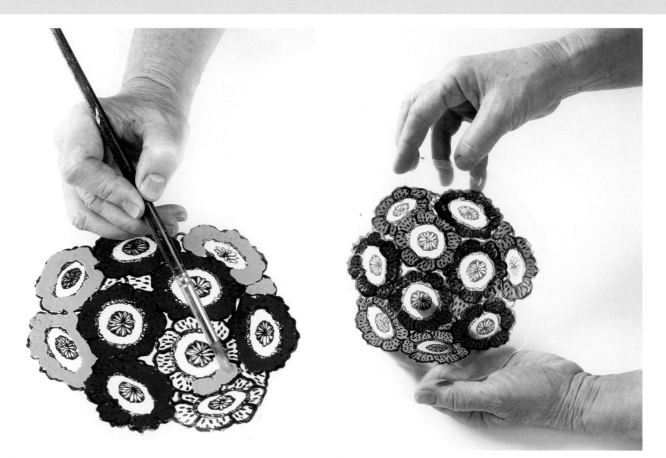

4 paint the image
Paint the back of the image. This will be the side directly applied to the substrate.

5 trim the excess acrylic skin
Cut and trim the edges with scissors, creating a clean shape.

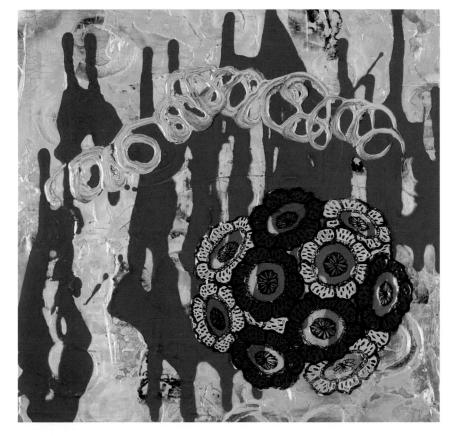

the finished example

I used Soft Gel (Matte) as my "glue" for attaching the transfer skin and the poured acrylic shape. Notice the transparent areas of the transfer skin allow the underpainting to show through.

selecting the best gel medium

Clear Tar Gel is great for basic image transfers because it gives you a thick skin with only one application. Be careful, though, because the copier paper may buckle. Another possibility is Polymer Medium (Gloss). You'll have to build a thick skin slowly, using several layers and letting the layers dry between applications.

examples of acrylic transfers

direct transfers over thick gel

This piece by Melanie Matthews is a great example of combining thick textured gel applications and direct laser transfers. The thick, crosshatched area was created with tinted Molding Paste and a sgraffito technique over a yellow base. The direct transfers were applied with Fluid Matte Medium; textured surfaces were glazed with thinned fluid acrylics.

Rhizome Model
Melanie Matthews
Acrylic on wood panel
20" × 20" (51cm × 51cm)
Photograph by Josee Turcotte

exploiting direct transfers

Here, artist Debi Pendell combined direct image transfers with drawings, stencils and painted papers. Some of her materials are found objects such as letters, photos, images and fabric. Other materials, such as painted papers, were created intentionally. The work evolved through the process of painting, glazing, photographing, drawing, transferring, gluing, writing, stitching and lacing.

Who Is Alexis
Debi Pendell
Acrylic and mixed media on canvas
30" × 30" (76cm × 76cm)
Collection of Alexis Roasco

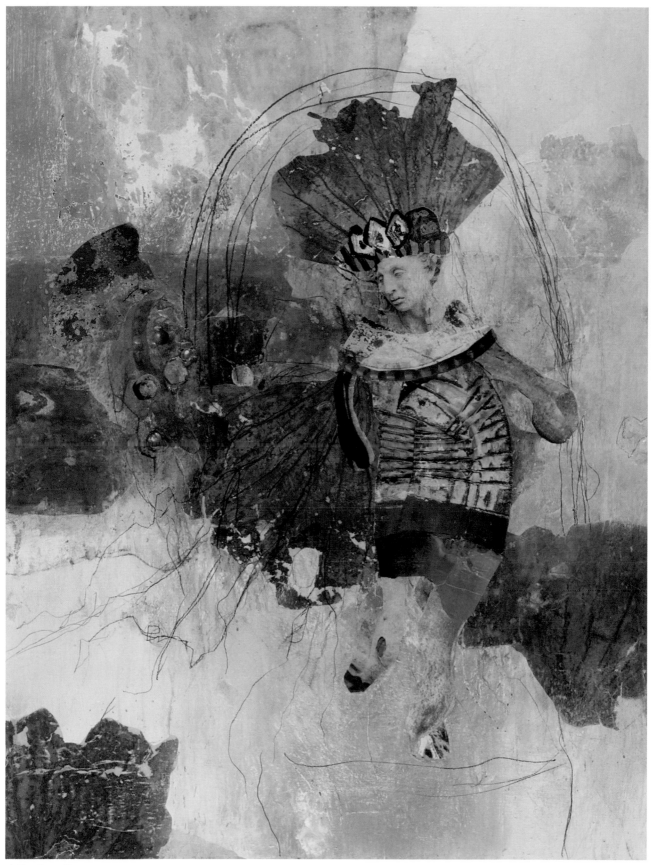

delicate collage

In this collage, artist Eydi Lampasona included several delicate acrylic skins, pieces of metal and drawings. The image transfers were applied over layers of molding paste of varied thicknesses and textures.

Amdalbergarden III
Eydi Lampasona
Mixed media on canvas
48" × 36" (122cm × 91cm)
Private collection
Photograph by Gerhard Heidersberger

Corrine Loomis-Dietz

I embrace the benefits of technology as I merge the world of paint and photography. I use a digital camera, computer, laser printer and photocopiers; however, I consciously attempt to minimize the time spent with machines, resisting the enticements of photo software programs. The bulk of my time is spent in the tactile world of paint and the many options of acrylic mediums, gels and grounds.

In my struggle to not be seduced by computer programs, I found an interesting way to use the photo source only as a reference to create highly unusual combinations of paint, texture, gel and image.

Artist Corrine Loomis-Dietz in her studio

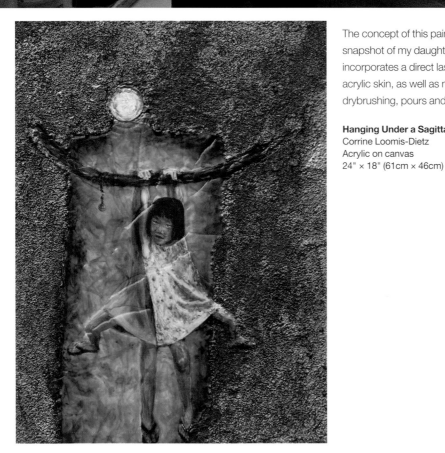

The concept of this painting began with a 4" × 6" (10cm × 15cm) snapshot of my daughter hanging from her swing set. This work incorporates a direct laser image transfer of my daughter onto an acrylic skin, as well as numerous acrylic painting techniques: glazing, drybrushing, pours and textured gels.

Hanging Under a Sagittarius Moon
Corrine Loomis-Dietz
Acrylic on canvas
24" × 18" (61cm × 46cm)

Creating the image transfer is one step in the construction of *Hanging Under a Sagittarius Moon*. I avoid using ink-jet prints because the ink is water-soluble and will blur when it contacts wet acrylic. Employing a black-and-white photocopy allowed me to manipulate the color beyond what the camera recorded.

burnishing the image onto the gel
After placing the image side of the photocopy directly on a wet layer of tinted Fine Pumice Gel, I lightly burnished the back to initiate consistent contact with the gel.

wetting the paper
Once the gel was thoroughly dry (this often takes a day or two), I wet the back of the paper with a warm, wet sponge.

removing the paper
I gently scrubbed the paper off, being careful to not damage the transfer, using sponges, pot scrubbers, my fingers or a soft cloth. It usually takes several rubbings to remove the paper.

cleaning up the surface
To remove the rest of the paper fiber, I used a wet cotton rag, rubbing in a circular motion. The image appears black when dry.

pours

WHEN YOU POUR PAINT, YOU EXPERIENCE

paint's physicality as it moves on its own without a brush or palette knife. We can't forget our debt to Jackson Pollock when we think of the poured line, or Morris Louis and Helen Frankenthaler with their beautiful thin pours that stained their canvases. Pouring is usually in the category of process painting, which is more about applying paint and the materials themselves and less about a final, pre-planned image.

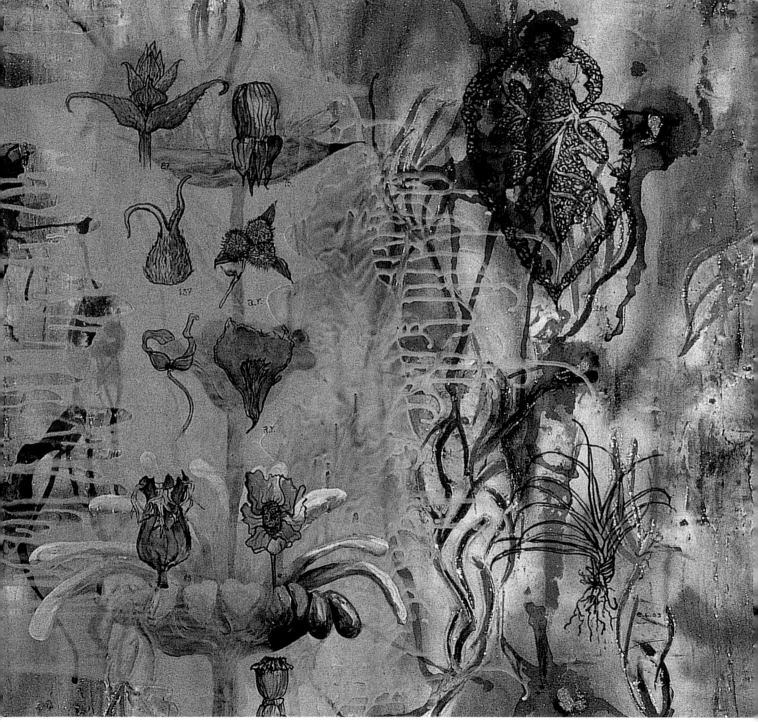

Florabunda Obatta (Detail)
Patti Brady
Acrylic on linen
Private collection

options for pours

Pouring can be a wildly unpredictable process for getting paint onto your surface. Even in the best planned circumstances, pours probably will not do exactly what you expect them to, so you should test and experiment with this technique before using it on your masterpiece.

pouring paint on canvas

Your substrate and its surface texture are important. Artists like Helen Frankenthaler manipulate poured fluid acrylic by tilting and turning the canvas. Thinned paints stain deeply into canvas. Thicker paints poured over the surface will mix together once the canvas is tilted. A less rigid surface like unstretched canvas may cause the paint to pool in the middle.

poured acrylic skins

Some artists pour volumes of low-viscosity gels and fluid acrylic paints directly onto surfaces that acrylic won't adhere to such as glass. Once dry, the painting is pulled up, and the edges of the poured paint become the edge of the actual painting, creating a big acrylic skin (see chapter 5).

gels and mediums for pours

··· **GAC 800** minimizes crazing and is a great medium for pouring, especially when tinted with paint. It has a hazy appearance when dry, so use a pour of GAC 800 when it can be tinted with a little bit of paint.

··· **GAC 500** is the thinnest leveling product and has less tack when dry, making it a good choice for creating poured acrylic skins. GAC 500 can be mixed with fluid acrylics.

··· **Self Leveling Clear Gel** has a resinous, stringy consistency, a great leveling property, and it dries to a high-gloss finish.

··· **Clear Tar Gel** is the thickest pouring gel. It dries very clear and is the best choice for creating detailed lines by dripping it over a surface. Generally, you can safely add 1 part water to 3 parts Clear Tar Gel with no major effects on film formation or chance of crazing. (See page 124 for more about the uses of Clear Tar Gel.)

crazing

Crazing is the formation of valleys like tiny riverbeds that run through an acrylic pour or puddle of paint. It happens when the acrylic skin begins to dry on the surface, but there is still fluid material underneath. As the water evaporates, the skin shrinks and tears until the entire film has dried.

clear topcoats

Many artists pour commercial two-part epoxies over their work, creating a clear, glasslike resin over their finished paintings. Poured epoxies lend incredible depth and color saturation to a piece, but are not considered archival materials.

Pourable acrylic gels are an archival alternative to epoxy pours, despite the limited depth a pourable acrylic gel can create. For a flat, clear pour, use a rigid substrate with minimal surface texture. If working on an extremely textured surface, do repeated thin pours, allowing each layer to dry thoroughly. The pours will take on the surface's texture as the water evaporates. Don't speed the drying time with a fan; slow drying conditions are best. (See page 79 for more on Gel Topcoats.)

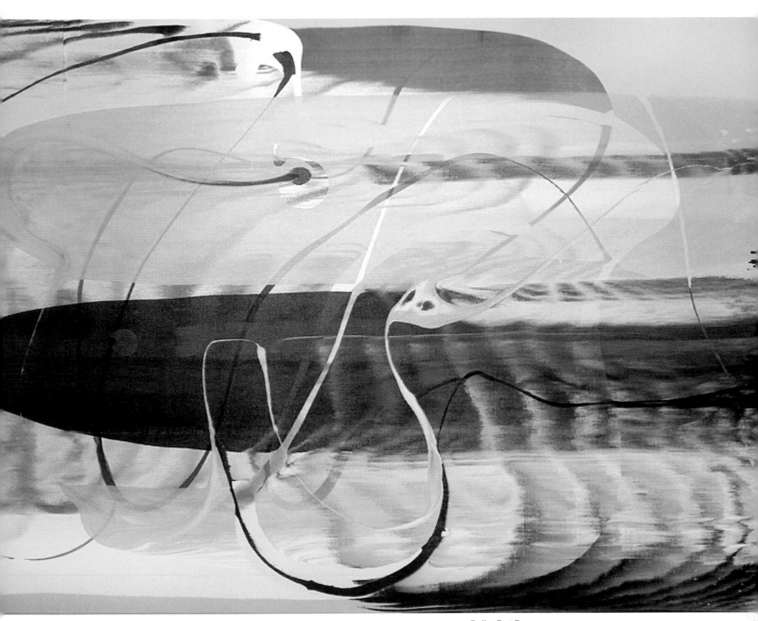

extreme poured lines

Artist Sara McIntosh pours lines, then scrapes and pulls them with large specialty squeegees. She lies face down on a custom-built platform, which an assistant then pulls or pushes as she manipulates the surface with a squeegee.

Polka Dot Door
Sara McIntosh
Acrylic on canvas
60" × 84" (152cm × 213cm)

pouring tips

··· Make sure your surface is level as it dries, because the gels and mediums will find their own level and dry to an uneven surface.

··· Don't move, bump or agitate the surface while it dries. Use a tentlike structure to protect surface from dust and bugs.

··· Don't overwork the paint, gel or medium. You will incorporate air bubbles or bits of dried film, resulting in a loss of clarity.

··· For a thick pour, spray a light mist of isopropyl alcohol over the surface to dissipate any foam. As more foam moves to the surface, apply another mist of alcohol.

··· When mixing color into pourable gels, allow the mixtures to sit for a few days to allow the foam to dissipate. To encour- age bubbles to rise to the surface and break, I take my jar, with the lid on, and bang it against a table, as you do with cake batter when baking a cake.

··· Ammonia is an essential ingredient of acrylic. As large sur- faces of pours are drying, the ammonia evaporates into the air, so make sure you have proper ventilation.

··· Pouring can be messy; cover the floor and keep the dog and cat out of the studio. My dog, Aggie, spent a few weeks covered in green spots that she collected when she walked under one of my dripping pours!

··· Keep a set of tweezers handy to extract that errant dog hair or fruit fly.

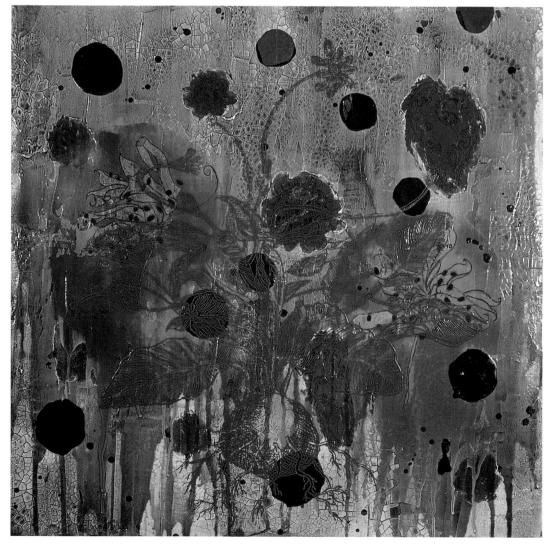

some things can be left to chance
This painting has numerous layers of techniques that include staining, washes, detail painting, drops, pours and dribbles of paint, direct transfers, gels and grounds. Some of the techniques were calculated, and much was simply left to chance and reworked according to how interesting it was and if it supported the resolution of the painting.

Primula/Primel
Patti Brady
Acrylic on canvas panel
23" × 23" (58cm × 58cm)
Collection of Ed House

wet-into-wet with thick pours

The look that artist Phil Garrett achieves with pours in this beautiful painting is unique to acrylic. This is a great example of how working wet-into-wet with thick pours of color can create highly inimitable surfaces. Thick layers have been rubbed back with alcohol, exposing color underneath. The single lily was painted with velvety Matte acrylic paint, which contrasts with the high gloss of the surrounding orange and green areas.

Day Lilies Strata
Phillip Garrett
Acrylic on canvas
18" × 18" (46cm × 46cm)

painting into a pour

Here you'll use Clear Tar Gel for a large pour over an underpainting consisting of multiple glazes, which provide the rich colors of the background. I painted the opaque teardrop shapes with fluid acrylics on a wood panel wrapped in canvas.

Before pouring, use a carpenter's level to check your table's levelness, and protect the table and floor from wayward drips. Consider keeping a large sheet of HDPE (high-density polyethylene) under your panels when doing a pour. The HDPE makes it much easier to clean up spills and drips, and it won't stick to your surface.

materials

FLUID ACRYLICS
Cerulean Blue Deep, Cobalt Teal, Cobalt Turquois, Green Gold, Naples Yellow Hue, Quinacridone/Nickel Azo Gold, Vat Orange

TOOLS
Carpenter's level, HDPE plastic, no. 10 synthetic round brush, palette knife, spray bottle filled with isopropyl alcohol, squeegee

SURFACE
Wood panel

OTHER
Clear Tar Gel

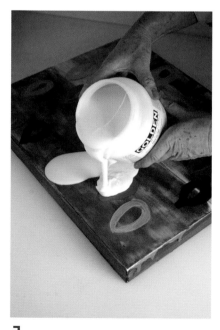

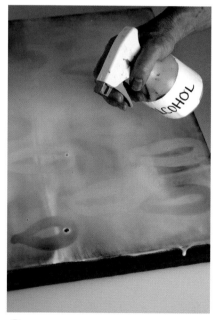

1 pour the clear tar gel
Pour a pool of Clear Tar Gel on the underpainting, making sure you have enough to cover the entire surface.

2 spread the tar gel
Use a large tool such as a squeegee to spread the gel over the surface. If you stopped at this point, you would have a clear, glossy topcoat for your painting.

3 mist the surface with isopropyl alcohol
Spreading Clear Tar Gel over the surface may create some foam, so spray a fine mist of isopropyl alcohol over the surface. The alcohol will cause any bubbles to pop.

4 brush on fluid acrylics

Load a synthetic round with fluid acrylic and pull it through the wet surface. Be playful and don't try to completely control everything. Let the paint move and the gel do its thing.

5 add details and let dry

Use the tip of a palette knife or another sharp tool to drag details of paint through the surface. You can work as long as the gel is wet. When you're finished, allow the piece to dry to a clear surface.

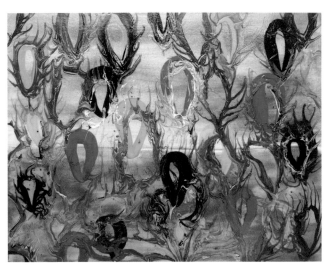

keep it fun and loose

As the gel dries, the milky quality will become clear and the streaks of color will appear very bright and rich. I let this piece dry with the panel not quite level. The bottom portion of the pour moved south, distorting the original shapes as it dried.

The different viscosities of paint created fissures and crevices, producing some very unusual effects. If you want to avoid fissures in your surface, pour a thin layer of gel over it. Allow that to dry, then continue to add thin layers, drying in between, until the surface is even.

another alternative

Here I experimented with different viscosities of paint by layering into a wet pour of Clear Tar Gel. I created a basecoat with several layers of color and stenciled gels. Then I painted Fluid Carbon Black circles into a layer of wet Clear Tar Gel and immediately tipped the surface, allowing some of the circles to drip down the edges.

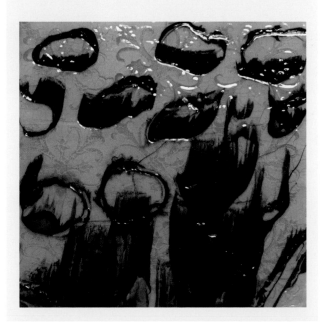

poured lines

For this demonstration, I decided to change the texture by creating a finely pebbled surface that would affect the flow of the pours. I also experimented with different viscosities of paint.

To prepare my surface, I spread Glass Bead Gel as thinly as possible with a palette knife over a basecoat of Fluid Naphthol Red Medium and let it dry. (A thin application of Glass Bead Gel will dry very clear, while a thicker application dries less clear.) The glass beads impart a pebbled, highly reflective surface, which will interfere and direct the flow of the pours of thin airbrush color.

materials

AIRBRUSH ACRYLICS
Bright Orange, Quinacridone Magenta, Titanium White, Turquois (Phthalo)

FLUID ACRYLICS
Cobalt Teal, Green Gold, Iridescent Pearl (Fine), Naphthol Red Medium, Pyrrole Orange, Titanium White

TOOLS
Palette knife, paper cups

SURFACE
Rigid support, such as a wood panel

OTHER
Glass Bead Gel

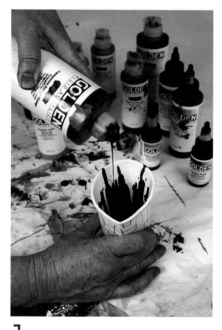

1 pour the acrylics into a paper cup

Pour layers of several fluid colors into a paper cup. Pour in one Airbrush color that will really stand out from the other fluid colors. Do not mix the colors; the fluids will stay in the bottom of the cup because of their heavier viscosity.

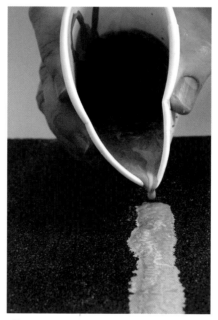

2 pour the colors onto the canvas

Pinch the cup's edge, then test the mixture on a piece of paper or your palette. If you like the mixture, slowly pour a line from the canvas's top edge to the bottom.

Notice how the blue Airbrush color seeps out of the pour and catches the uneven surface created by the Glass Bead Gel, creating a wavy pattern around the inner stripe.

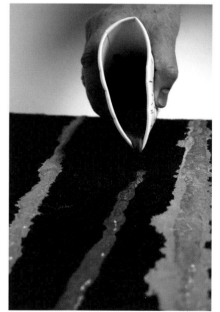

3 create another batch of fluid and airbrush colors

Repeat the procedure in steps 1 and 2 using a clean cup wtih different fluid and Airbrush colors. Pour this new selection of colors between the first poured lines. Let the paints do their magic.

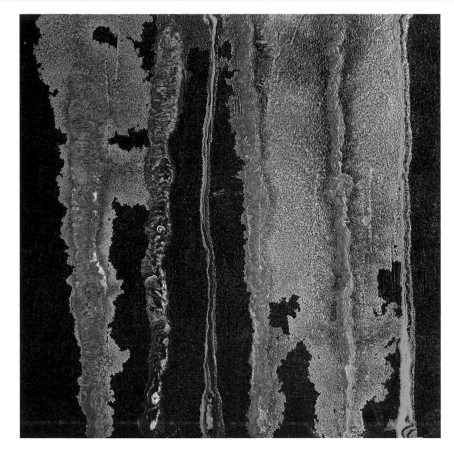

dramatic poured lines

The bleeding of the Airbrush color is quite dramatic. The blue Airbrush color spreads out and begins to seep into the adjacent stripe. The orange floats out, bleeding in both directions and tinting the wet pours on either side.

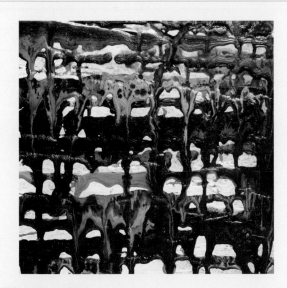

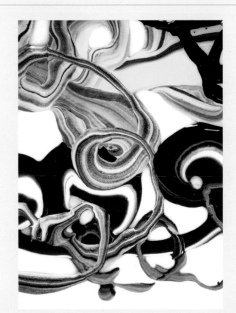

tilting the surface

After I poured the paint lines, I tipped the wet surface, allowing the colors to drip together. The thinner Airbrush colors moved out and down more quickly than the heavier fluid colors. The tension created by the different viscosities during drying resulted in a curdled surface.

loop-de-loop

Here, I poured in a loop-de-loop pattern on a flat surface, letting the color settle and nudge each layer together.

Patti Brady

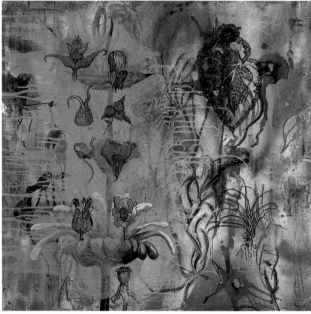

Having land on which to plant a garden led to an interest in old botanical drawings and spurred a morning ritual of drawing from my garden. I think that *Florabunda Obatta* captures my excitement with a new landscape, but it also expresses the great joy I feel from knowing my medium and having the confidence to push and experiment with it.

That said, I'm never exactly sure where a painting is going when I begin. After I prime the surface, I choose a color to paint the canvas and sides of the stretcher bars. I primed this painting with Fluid Red Oxide, brightened with Indian Yellow Hue in honor of the red clay soil of the South.

Florabunda Obatta
Patti Brady
Acrylic on linen
36" × 36" (91cm × 91cm)
Private collection

creating a fissured surface

Force-drying a thick layer of Self Leveling Clear Gel with a fan caused the top layer to dry quickly, leaving a fluid center. The tension on the top layer caused it to crack and pull, creating a fissured surface. If you want an even surface, let the acrylic dry as naturally as possible; don't force it with a fan or hair dryer.

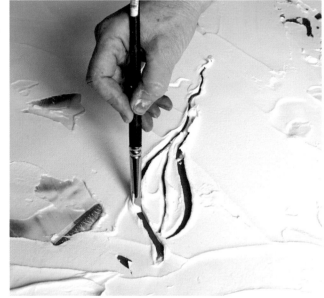

carving into the molding paste

Next, I applied a thick layer of Light Molding Paste with a large pastry knife. I used a colour shaper to draw organic shapes into the wet Molding Paste, exposing the orange underpainting. I left deep edges so the surface would have voids that the next stain could pool in.

After this dried, I dampened the surface (for deep saturation) and stained it with several layers of thinned fluid acrylics, allowing each layer to dry before adding the next. I built layers of stains until I felt ready for another step.

When the stains were dry, I poured GAC 800 over the entire surface, using a palette knife to spread the pour. This created a glossy, glasslike surface.

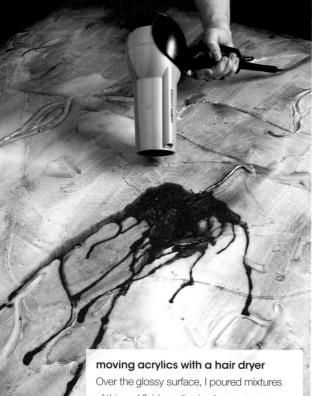

moving acrylics with a hair dryer
Over the glossy surface, I poured mixtures of thinned fluid acrylic in chosen areas, then used a hair dryer to direct the flow. The rust and green spider effects were the result.

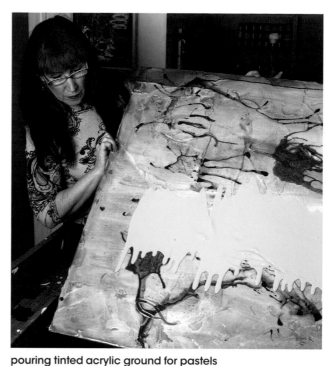

pouring tinted acrylic ground for pastels
Next I poured Acrylic Ground for Pastels tinted with various thinned fluid acrylics. Acrylic Ground for Pastels isn't designed for pouring; it cracks when applied thickly—which is exactly what I wanted! I then tilted the canvas to move the pour in the direction I wanted. This wasn't the most precise pour, but with the high-gloss surface, I could wash this pour off and begin again if I didn't like what had happened.

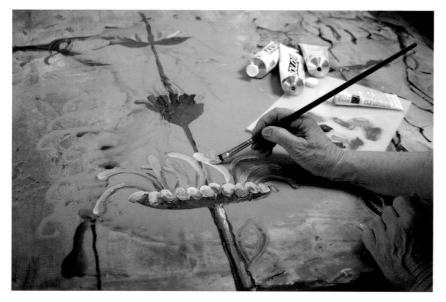

painting on the pour
When this layer was dry, I painted a water-fountain-like plant with heavy body paints using a more traditional, painterly application, moving thick color with brushes. I liked the idea of letting the paint and gels do what they would and then parking a traditionally painted object among the more spontaneous applications.

After another pour over the fountain plant and many detailed botanical drawings later, I felt that this was a finished painting. I chose not to varnish it, as any application of varnish would consolidate the surface of the painting. I wanted the glossy areas to play off the matte pours.

acrylic
encaustic

ACRYLIC IS A TOTALLY DIFFERENT ANIMAL

than beeswax; however, acrylic can create beautiful trans-

parent and translucent layers that simulate the seductive

quality of encaustic. Some of the luminous colors and lush

surfaces produced with beeswax are easily reproducible

with acrylics. Many artists use acrylic gels simply because

they create stunning multidimensional effects—even

when they aren't trying to copy the look of beeswax.

Circular Chaos (Detail)
Barbara De Pirro
Acrylic on wood panel

options for acrylic encaustic

I've found there is no "one" encaustic look. Artists who are interested in working with encaustic but are unable to provide the proper ventilation may find acrylics a viable alternative.

Many acrylic gels can appear waxy like encaustic. This is especially true of the matte products. High Solid Gel (Matte) is particularly good, as it is very stiff and dries to a waxy, trans-lucent surface. Adding small amounts of Fine Pumice Gel or Acrylic Ground for Pastels will change the level of matting agents, creating the milky, diffused transparency that characterizes encaustic surfaces. Experiment to discover your own formulas.

unrefined "beeswax" yellow "beeswax" refined "beeswax"

unrefined "beeswax" yellow "beeswax" refined "beeswax"

acrylic "beeswax" formulas

Below are three formulas that you would apply over a finished painting and create effects reminiscent of beeswax. The different viscosities of the formulas create different surface textures, as will the technique with which you apply them. Always test your formula on a sample and allow the mixture to dry, as there is a color shift from wet to dry.

··· **Unrefined Acrylic "Beeswax":** Add 6 drops of Fluid Interference Blue (Fine) and 1–3 drops of Fluid Quinacridone/Nickel Azo Gold to 8 ounces (227g) of High Solid Gel (Matte). This formula creates a thick "wax" with a stiff viscosity in a bright, cool, translucent yellow. Apply with a wide palette knife.

··· **Yellow Acrylic "Beeswax":** Add 2 drops of Fluid Naples Yellow Hue, 1 drop of Fluid Quinacridone/Nickel Azo Gold and 2 drops of Fluid Interference Oxide Red to an 8 ounce (227g) jar of Soft Gel (Matte). This creates a "wax" with the viscosity of yogurt and the color of warm liquid beeswax.

··· **Refined or Bleached Pourable Acrylic "Beeswax":** Combine 2 ounces (57g) of Soft Gel (Gloss) with ½ ounce (14g) of Soft Gel (Matte). Add 1½ ounces (44ml) of water, then 4 drops of Fluid Interference Blue (Fine) and 1 drop of Fluid Iridescent Gold (Fine). Let the mixture sit overnight. This creates a "wax" with a smooth, matte surface with minimal color.

adding an "aged" patina

The Yellow Acrylic "Beeswax" formula has the perfect viscosity for creating the soft, warm folds of hot wax spread over a surface. Apply Yellow Acrylic "Beeswax" over the surface with a pastry knife, spreading the formula to create the texture.

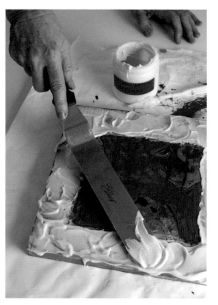

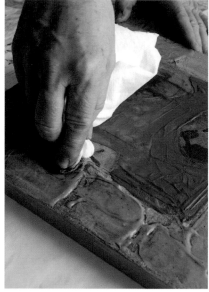

slather on the "beeswax"
Here you can see how thickly the Yellow Acrylic "Beeswax" is applied to the painting's edges. Although this looks incredibly thick, acrylics lose volume as they dry (because the water evaporates), so go ahead and slather it on then let it dry.

apply the patina with a cloth
Acrylic Glazing Liquid (Gloss) gives the patina mixture a long open time, so if you've chosen a color of glaze you don't like, just wipe it up and begin again.

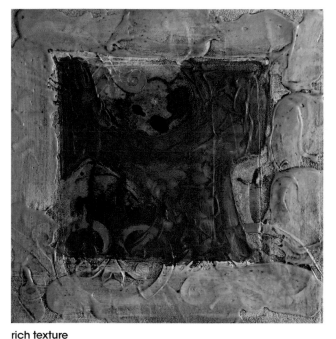

rich texture
The finished example is rich with texture, and looks as if the "beeswax" was melted on.

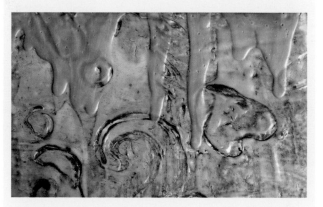

intarsia

Intarsia is a woodworking term for a panel that has been incised to form a channel that is then inlaid with a contrasting piece of wood. Intarsia is also a great technique for encaustic because the soft wax can easily be carved out. More wax can be added if the excavation is deep, or oil paint can be rubbed into fine lines. Acrylics may be used for intarsia effects as well. It's a bit more complicated to carve into a dry acrylic surface, though it can be done (see chapter 4). Here the carving is performed while the acrylic is still wet.

materials

FLUID ACRYLICS
Chromium Oxide Green, Naples Yellow Hue

HEAVY BODY ACRYLICS
Cobalt Teal

TOOLS
Colour shapers in various sizes, soft cloth

SURFACE
Wood panel or canvas over board

OTHER
Acrylic Glazing Liquid (Gloss), Heavy Gel (Matte), High Solid Gel (Matte)

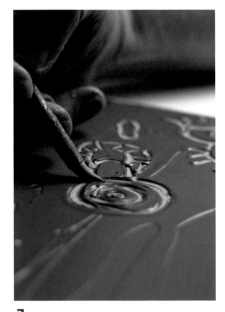

1 prepare the surface and incise a pattern

Over a dry basecoat of Naples Yellow Hue, use a wide colour shaper to apply a mixture of 3 parts Heavy Gel (Matte) to 1 part Chromium Oxide Green. While wet, incise a pattern with a pointed colour shaper so the basecoat shows through. Frequently wipe off the colour shaper's end for clean lines. Let this dry.

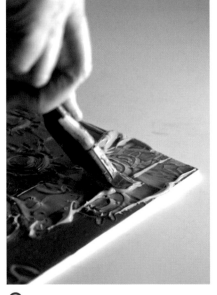

2 paint over the incisions

Mix 3 parts High Solid Gel (Matte) with 1 part Heavy Body Cobalt Teal. Spread the mixture in deeply into the incisions with a wide colour shaper. Scrape in different directions, pushing the mixture deep into the channels.

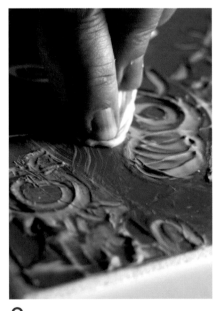

3 touch up the surface

Dampen a soft cloth with Acrylic Glazing Liquid and use it to remove the Cobalt Teal mixture from the areas surrounding the incision.

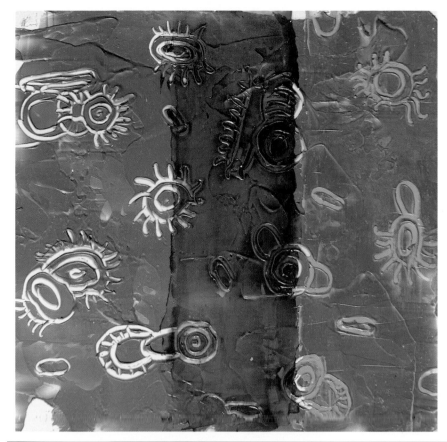

intarsia options

The basecoat of Fluid Naples Yellow Hue peeks through the carved lines. On the left, the yellow channels remain empty. On the right, the thick mixture of High Solid Gel (Matte) and opaque Cobalt Teal paint blocks out the yellow base. In the middle, I applied a stripe of Pyrrole Orange, a transparent pigment, which allows the yellow to glow through, creating more depth and richness of color.

multiple intarsia layers

In this example, I created multiple layers using the intarsia technique. Each layer has different color combinations and varying sizes of incised lines. The layered colors and textures create a rich yet mysterious effect.

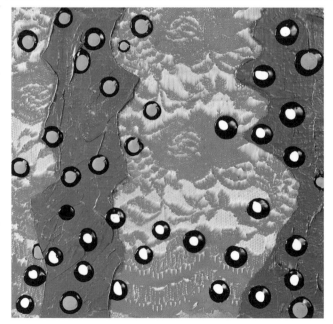

the possibilities are endless

Here, multiple layers of gels create a translucent waxy depth. Over a basecoat of Fluid Iridescent Bronze, I applied Molding Paste over a lace stencil. Over that, I layered Heavy Gel (Matte) tinted with Heavy Body Cobalt Titanate Green. I mixed two pink colors with fluid acrylics and thickened them with Heavy Gel (Matte). Finally, I simply dripped pure fluid colors, which look like drops of hot wax, onto each other while wet. There's no end to the ways you can explore the effects of acrylic encaustic.

acrylic encaustic examples

a milky translucency

I love how artist Debi Pendell achieves the encaustic look with a series of gels. In this painting, the sheen and color are close to that of bleached beeswax, minus the yellow. Debi achieves this beautiful, milky translucency by alternating layers of High Solid Gel (Matte) or High Solid Gel (Gloss) and Self Leveling Clear Gel or Fluid Matte Medium. She creates texture with the stiffer gels, then plays with the color, glazes and image, eventually leveling out the texture with lower-viscosity gels.

Translucency
Debi Pendell
Mixed media collage on canvas
24" × 24" (61cm × 61cm)

a waxy sheen without the wax

Two versions of pine knots, using several layers of alternating pours of Clear Tar Gel, swatches of Light Molding Paste, thinned Acrylic Ground for Pastels, and washes and stains with fluid acrylics. Although I was not trying to create an encaustic look, these two paintings are often mistaken for encaustic paintings.

Eve's Weed Midnight
Patti Brady
Acrylic on wood panel
12" × 12" (30cm × 30cm)
Private collection

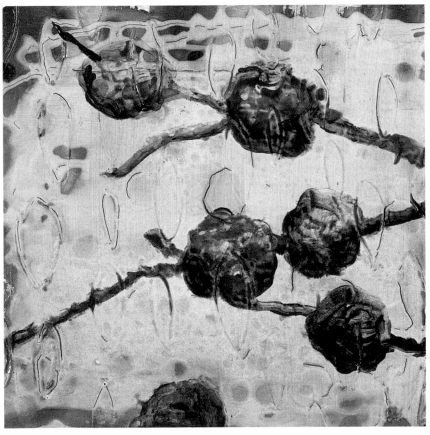

Eve's Weed
Patti Brady
Acrylic on wood panel
12" × 12" (30cm × 30cm)
Private collection

Barbara De Pirro

ARTIST PROFILE

Having recently moved from a very urban setting to a rural water-front, I found myself submerging emotionally and creatively into this beautiful environment. I spent hours digging into the soil and sculpting the landscape into gardens and pathways. In this process, I began arranging collections of plants, stones, shells and wood, both indoors and out. Studying these three-dimensional forms, I sketched and photographed each shape and arrangement. I then began to work my images until an idea developed, ultimately inspiring a new series of paintings.

Artist Barbara De Pirro at work in her studio

preparing the support and creating texture

I use wood supports because their rigid surface works best for multiple thick layers. I seal the surface with two coats of GAC 100, allowing each coat to dry between layers. I then apply 2 coats of white gesso, drying between coats. I create a textural surface using Light Molding Paste and allow the piece to dry overnight.

staining the surface

I extend fluid acrylic paints with water, which allows them to pool, puddle and soak into the Light Molding Paste. Before applying the paint, I mist the surface with water, then apply the paint with a wide brush, letting each layer of color dry before applying the next. I'll repeat this process, rotating the painting until the desired effect is achieved. With this technique, I've found I can create surfaces that reflect those found in nature, such as eroded or weathered surfaces or mineral deposits.

Circular Chaos is one of the first in a series where I began translating forms onto hand-painted paper. I then cut and glued the paper onto a textured surface, coating and embedding the entire piece with deep translucent layers of gel.

Circular Chaos
Barbara De Pirro
Acrylic on wood panel
18" × 12" × 2½" (46cm × 30cm × 6cm)

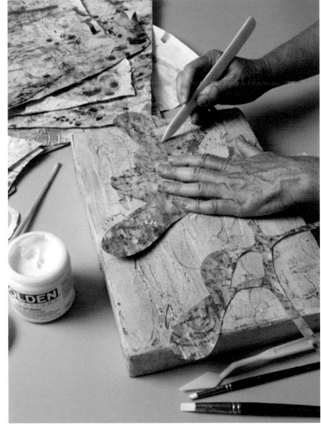

creating a paper design

I create my own painted papers using a combination of simple techniques. Once I've selected the paper for my painting, I sketch out my design on tracing paper, then transfer the image onto the back of the paper. This way I can see the lines more clearly, and I don't need to erase them afterwards. I cut the design out with a fine knife blade, which I can freely move around more detailed forms.

finishing the painting

I brush Soft Gel (Matte) on the paper's backside, then adhere it to the surface. Once papers are positioned on the surface, I gently burnish out the wrinkles and excess gel and allow the piece to dry overnight.

Next, I brush a thin coat of Soft Gel (Gloss) over the surface to acheive a consistent acrylic film. I then apply a thick coat of the Heavy Gel (Gloss) using a palette knife, adding texture as I apply. I let this dry for a couple days, then I brush on a thin coat of Soft Gel (Semi-Gloss) or Soft Gel (Matte). This reduces the shine without obscuring the image underneath.

metallic & reflective paints

THESE PIGMENTS OFFER AN ENTIRELY new range of color and play of light. Mixed with color, as an underpainting, as a glaze, sandwiched between glasslike pours of gel, swirled in thick passages of heavy impasto, they can create stunning optical illusions that traditional pigments can't produce.

In this chapter you'll discover a range of artists who use these pigments creatively, incorporating them into their work in vastly different ways. You'll discover some great technical information that might inspire new ideas. We'll look at some of these paints individually and explore their unique qualities. Technically, metallic and reflective paints fall into three categories: iridescent, micaceous and metallics, and interference colors.

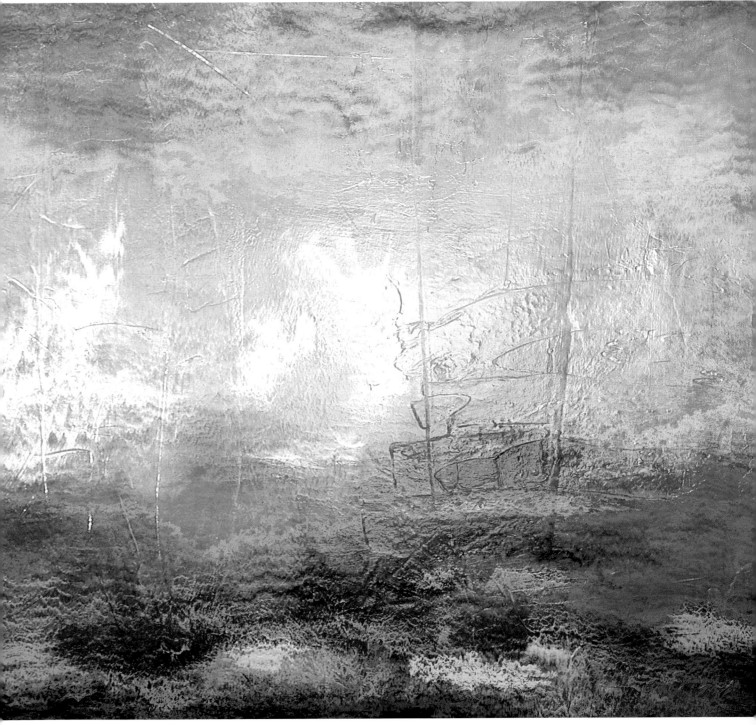

Energy Field With Ocean (Detail)
Nancy Reyner
Acrylic on wood panel
Collection of Ray and Kristin Jette

iridescent colors

The iridescent group represents particles that capture the luster of gold, bronze, copper, silver and pearl, but are not true metals. These pigments contain mica platelets coated with a very thin layer of iron oxide that imparts a metallic look. Since these colors are not made with actual metal, they will not oxidize when exposed to air.

Iridescent colors are available in both heavy body and fluid viscosities. Within the collection some colors are labeled *fine*, indicating a smaller mica chip that imparts a satin, nacreous surface. Other colors are labeled *coarse*, indicating a larger particle that imparts a glittery appearance to the paint.

Iridescent Stainless Steel (Coarse) + Dioxazine Purple

Micaceous Iron Oxide + Hansa Yellow Medium

Iridescent Copper (Fine) + Anthraquinone Blue

Iridescent Pearl (Fine) + Transparent Pyrrole Orange

Interference Oxide Green (BS) + Quinacridone Red

Interference Oxide Red + Quinacridone Violet

Interference Oxide Green (BS) + Indian Yellow Hue

mixtures of iridescent, micaceous, metallic and interference colors

Here I've mixed either one iridescent or one interference color with one fluid acrylic color, then thinned the mixtures with water. When enough water is added, the staining pigments of the fluid colors will soak deeply into an absorbent surface, while the iridescent or interference pigments will sit on the surface.

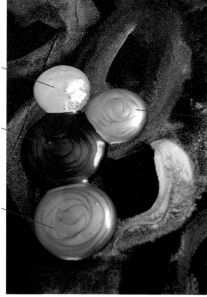

Iridescent Pearl (Fine)

Iridescent Copper (Fine)

Iridescent Bright Gold (Fine)

Iridescent Silver (Fine)

iridescent paints

Here, droplets of fluid iridescent acrylics sit on washes of iridescent and interference colors. The dark black surface is a layer of Iridescent Micaceous Iron Oxide.

iridescent bronze (fine)

Here thinned Fluid Iridescent Bronze (Fine) was brushed on a dry sheet of watercolor paper. The paint was flooded with water to create some unusual staining effects. The water lifts the Phthalo Green (Blue Shade) out of suspension and creates a stain, or halo effect, around the heavier bronzed mica flake.

iridescent colors at work

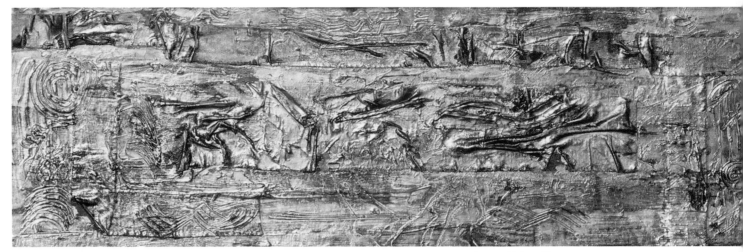

light and form

Here layers and washes of Iridescent Copper Light (Fine) and Fluid Turquois (Phthalo) were flooded over the surface. After it dried, the artist made numerous color corrections with an assortment of other fluid iridescent colors. The effect is similar to sheets of hammered metal.

Canyon Majesty III
Teyjah McAren
Acrylic on board
10" × 30" (25cm × 76cm)
Collection of Don Bergman

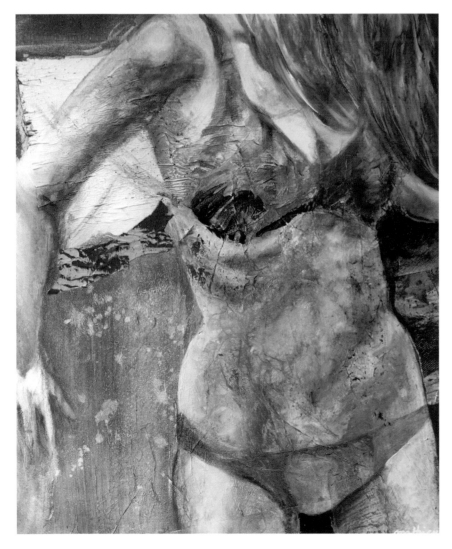

luminous flesh tones

Here French painter Mathieu Emmanuel uses the unique properties of Iridescent Bronze (Fine) for flesh tones on the torso.

Par Dessus l' Épaule
Mathieu Emmanuel
Acrylic and collage on linen
23¾" × 19¾" (60cm × 50cm)

micaceous and metallic colors

Unlike iridescent colors, the micaceous and metallic category includes actual metals. Stainless Steel, Micaceous Iron Oxide, Coarse Alumina, Black Mica Flake, Gold Mica Flake and Pearl Mica Flake are all made from naturally produced mica flakes mined from the earth.

With Heavy Body Smalt Hue

With Fluid Nickel Azo Yellow

With Heavy Body Alizarin Crimson Hue

With Fluid Turquois (Phthalo)

With Fluid Titanium White

With Fluid Iridescent Bright Gold (Fine)

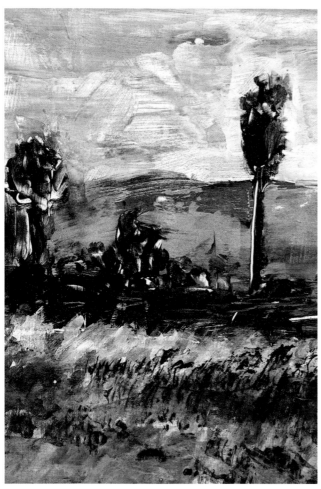

adding mood and texture

In this landscape, Micaceous Iron Oxide enhances the look of the other colors, contributing to the mood of the piece. Micaceous Iron Oxide also adds a distinctive textural element, which is very visible where applied thickly.

micaceous iron oxide mixtures

Micaceous Iron Oxide has a rich black color when used thickly, while a thin application reveals a warm, violet-brown undertone. The mica in this paint creates a glistening reflective sheen. When mixed with other paint colors, it produces an earthy, grainy color speckled with glints of reflected light. The heavy body version of Micaceous Iron Oxide imparts texture when applied as a ground, while the fluid version has an exceptional viscosity for glazes and washes.

With Indian Yellow Hue

With Anthraquinone Blue

With Quinacridone Burnt Orange

With Naples Yellow Hue

With Cobalt Teal

With Manganese Blue Hue

stainless steel

This example shows a sampling of pigments mixed with Iridescent Stainless Steel (Coarse). This pigment is made of high-grade stainless steel, and is just as rust-resistant. Mixed into color, it adds a metallic gray speckle—an interesting way to "gray down" a color.

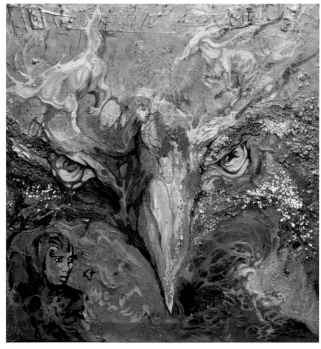

sprinkled gold mica

Here Gold Mica Flake is sprinkled into areas where the head of a bird seems to explode and dissipate, contributing to the fantastical images on the surface.

Lana Fich
Jean Luc Toledo
Acrylic on canvas
27½" × 26½" (70cm × 67cm)

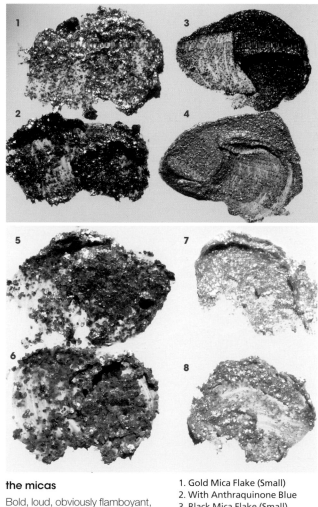

the micas

Bold, loud, obviously flamboyant, in your face—these are the micas. They add texture, light and glitz to any work.

1. Gold Mica Flake (Small)
2. With Anthraquinone Blue
3. Black Mica Flake (Small)
4. With Iridescent Bright Gold
5. Gold Mica Flake (Large)
6. With Green Gold
7. Pearl Mica Flake (Small)
8. With Phthalo Green (Yellow Shade)

interference colors

Interference colors are made from mica platelets with a thin transparent coating of titanium dioxide. The effects you see occur because of the refraction, reflection and interference of light. This line includes Interference Blue, Gold, Green, Orange, Red and Violet. The colors that you see with interference paints occur because light is moving through different densities of transparencies. You can see this phenomenon at work in the rainbow colors swirling on the surface of a rain puddle in an oil-soaked parking lot, or in the changing colors of the wings of butterflies, birds and beetles.

Because the effect is dependent on light moving through transparent layers, using gels with a glossy sheen will maximize the effect. Mix small amounts of an interference color into the gel to suspend it in transparent layers. Using an interference color full strength creates a more frosted look with less brilliance, so use small amounts, building transparent layers. Gels with a matte sheen tend to block the light and deaden the effects.

understanding interference colors

Photographing interference effects is difficult. They can be truly appreciated only when viewed in person. There are some basics to understand that will help you to use interference colors more effectively.

1. Interference color reacts differently over a dark basecoat than it will over a light basecoat. Over a light base, the interference color will flip back and forth to its complement; either you or the paint must change angle in order for you to be able to see the shift. Over a dark base, the interference color will reveal its hue. Instead of a black ground, try substituting a coat of Micaceous Iron Oxide, Coarse Alumina or Dioxazine Purple, unusual dark colors that interplay beautifully with interference paints.

2. Any interference color mixed with a black pigment will reveal its hue. Here Interference Violet (Fine) is mixed with Fluid Carbon Black. The mixture reveals the violet hue and loses its "flip" over the white.

3. Interference loses its complementary flip when mixed with pigment. Here, Interference Violet (Fine) is mixed with Phthalo Green (Yellow Shade), which causes the paint to lose its flip over the white surface. Over the black, however, you can see a sheen of violet.

4. Mix interference paint with other pigments for interesting reflective qualities. Here Iridescent Bright Gold (Fine) is mixed with Interference Violet and Phthalo Green (Yellow Shade). Although, many of the qualities of the interference flips are defeated by the addition of more pigment, there still remains a curious and seductive luster that is unique to the optical qualities of interference colors.

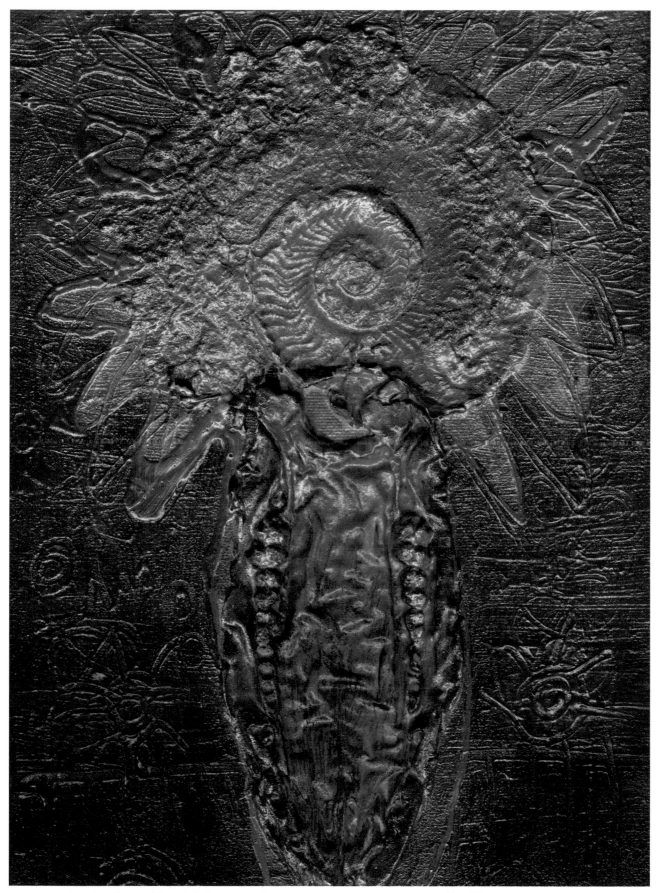

visual excitement from interference colors

Here the artist uses multiple overlapping glazes of interference paint, transparent pigments and gloss gels. The embossed surface increases the visual excitement of the interference flips in color.

Foss Hill
Jean Luc Toledo
Acrylic on paper
13" × 8½" (33cm × 22cm)

iridescent and interference underpainting

As with interference colors, using basecoats under iridescent colors can add interest to your painting. For instance, Ultramarine Blue under Iridescent Stainless Steel (Coarse) will enhance the metallic look, while Pyrrole Red under Iridescent Bright Gold (Fine) creates a gold leaf effect.

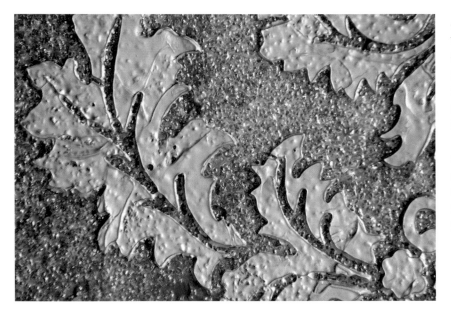

clear granular gel basecoat

The blue basecoat was covered with Clear Granular Gel, followed by a glaze layer of Interference Violet (Fine). The gel and the basecoat enhance the effect of the interference color and the pebbled surface allows the light to hit the interference at myriad angles.

Although it's not recommended to add matting agents to iridescent colors, here the mixture of Iridescent Silver (Fine) and Heavy Gel (Matte) create a feltlike surface. Pushing the limits of recommended practices is not necessarily a bad idea.

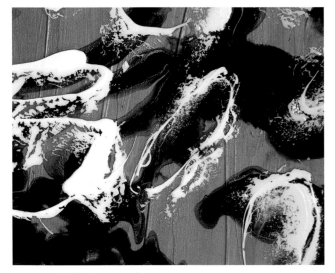

green metallic basecoat

Here, a Chromium Oxide Green basecoat sits under a mixture of Interference Green, Iridescent Bronze (Fine), Green Gold and Iridescent Bright Gold (Fine), which was extended with Polymer Medium (Gloss). In this example I stayed with the same family of green hues, enhancing the cool colors.

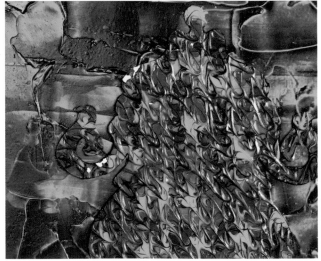

textured surfaces show off interference and iridescent paints

In this example, Cobalt Teal was mixed with Molding Paste to create a textured surface, providing more angles for the light to catch and reflect the mixture of interference and iridescent paints.

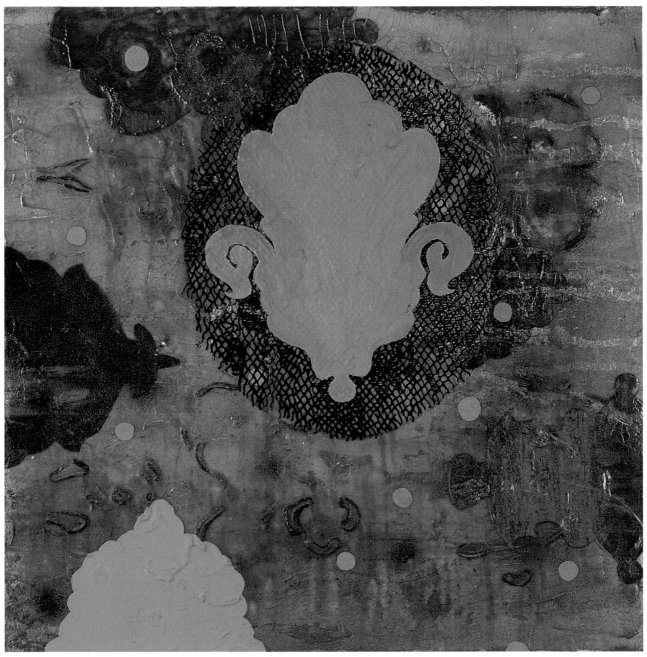

a grit that shines

A glaze of Micaceous Iron Oxide was washed over the entire surface of this painting to provide a gritty, gray tone. The raised patterns on the surface are glazes of Micaceous Iron Oxide, Iridescent Silver (Fine) and mixtures of interference and iridescent paints that shift in color and reflectiveness as you change your viewing angle.

Pink Flesh and Fish Nets
Patti Brady
Acrylic on panel
18" × 18" (46cm × 46cm)
Photograph by Eli Warren

gold leaf

I have tried to use acrylic to "fake" gold leaf, but it's difficult to compete with the tissue-paperlike thickness of the real stuff. Here are some important tips for combining gold leaf or composite leaf with acrylic painting.

··· Use traditional leafing sizes to attach the leaf to your surface. Acrylic will dry too fast, and it's not tacky enough the get the adhesion you need.

··· When you're applying gold leaf over a painted acrylic surface, allow the acrylic to dry thoroughly. Very glossy acrylic surfaces will be slightly tacky, and could result in the leaf inadvertently sticking to unintended areas.

··· Acrylic is water-based. The water will tarnish gold leaf, especially imitation gold leaf, and other metallic leaf. A coat of MSA Varnish, which has a mineral spirit base, will effectively seal the leaf. You can then layer acrylic over the MSA Varnish.

··· A great final coating for gold leaf is MSA Varnish with UVLS. Most metals, including gold, are not as high gloss as the gloss varnish, which, in turn, makes the surface look like it's coated with plastic. A mixture of MSA Varnish (Gloss) and MSA Varnish (Satin) will create a coating that offers a more realistic look.

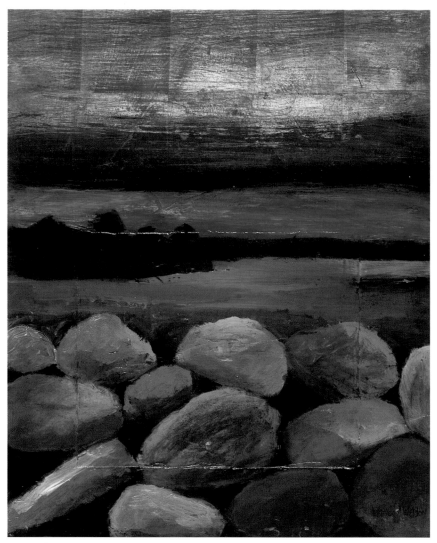

twenty-four carat surface

Here gold leaf was applied with a water-based gold leaf adhesive. As the painting developed, another layer of gold leaf was applied in the upper portion of the composition. It was sanded and painted, and then gold leaf was reapplied. The artist used two isolation coats of Soft Gel (Gloss), then one coat of Polymer Varnish (Gloss). Gold leaf doesn't need a varnish, but it makes sense to apply a varnish over the entire surface for unity.

Lighted Stone Wall
Wendy Weldon
Acrylic and gold leaf on panel
20" × 16" (51cm × 41cm)
Private collection
Photograph by Ron Hall

Nancy Reyner

I think of my paintings as versions of heaven. Rather then re-creating the images of Renaissance religious art, I strive to paint places that are beautiful and meditative. Oceans and skies are favorite subjects for me because they're easily recognizable as both meditative and heavenly. Reflective paints, which catch or reflect the light differently than regular pigmented paints, are natural additions to my palette, and add an entirely new dimension to the work. During my most recent painting show, gallery attendees appeared to be dancing in front of the exhibition as they viewed the paintings from different angles to watch the colors shift. The reflective paints are fairly new on the market, and are quite fun to both use and view in artworks.

Artist Nancy Reyner in her studio in New Mexico
Photograph by Daniel Barsotti

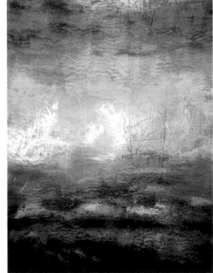

The shifting nature of interference colors gives this single painting several changing appearances.

Energy Field With Ocean
Nancy Reyner
Acrylic on wood panel
30" × 40" (76cm × 102cm)
Collection of Ray and Kristin Jette

This use of a tonal underpainting imitates one of the Old Masters' techniques called *grisaille*, which is an underpainting that uses several shades of gray. This grisaille started with an underpainting using combinations of blue, black and umber for the darks, and a light cream or ochre for the lights. These colors, when used either as mixtures or on their own, create various gray tones. Over this, thin, transparent glazes of color were applied, which shift in appearance over the varying tones of gray. Dark and light iridescent paints were substituted for the traditional pigments that the Old Masters used.

preparing the surface

Here I'm using a wood panel, which is braced in the back to minimize warping and cradled at the sides for easy grip and handling. I wipe the wood panel free of sawdust using a damp, lint-free rag, then brush on three coats of GAC 100, letting each coat dry before applying the next and lightly sanding the surface between applications.

I then apply two coats of acrylic gesso, letting each coat dry before applying the next. This added adhesion is important, since the surface will receive multiple paint layers. To inhibit future warping of the wood panel, I apply the same amount of GAC 100 and gesso to the panel's back side.

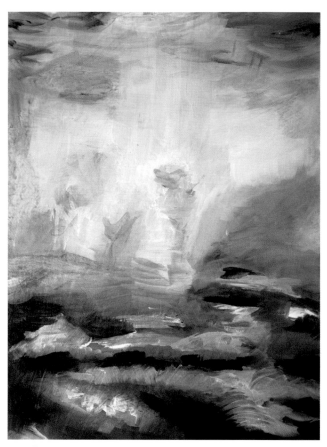

creating an underpainting

I create an underpainting with a range of lights and darks, using a limited palette of grays, black and white. This creates the basic underlying framework for the ocean waves and cloud formations, which add drama and movement to the composition.

I use Micaceous Iron Oxide for the darks and Iridescent Pearl (Fine) for the lights. I use them separately or in combination to obtain a full range of gray tones. I also add a slow-drying medium to these mixtures so they stay wet longer.

I then expand the variety of tones in the underpainting by adding some more reflective paints, such as Iridescent Stainless Steel (Coarse) and Iridescent Silver (Fine). White can also be added to the palette, but should be used sparingly as it will inhibit the reflective quality when used opaquely or too heavily with the iridescent paints.

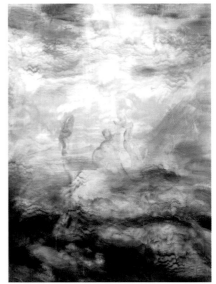

adding texture

Once the general dark and light patterns are in place, I use tools such as palette knives, rubber shapers, nails or old credit cards to create texture and interesting lines. These effects create the misty atmospheric areas. Once the underpainting is complete, I let it dry overnight.

details convey movement

These textural line details bring the ocean waves to life.

adding glazes of color

On top of the dry underpainting, I add glazes of color, using several mixtures prepared ahead of time. These transparent glazes subtly tint the tones in the underpainting without covering them. My glaze mixtures consist of 1 part of any colored paint, to 8 parts of a slow-drying medium. Adding an additional 1 part of an interference paint increases the reflective quality. Another option is to replace the colored paint in the glaze mixture with reflective paints that are inherently colorful, such as Iridescent Copper (Fine), Iridescent Bronze (Fine) or Iridescent Gold (Fine). Apply as many glazes as necessary to bring a full range of color to the underpainting.

Add a glossy finishing coat of acrylic on top of the painting after it has fully dried for two to three days. After that has dried, add a final coat with Archival MSA Varnish (Gloss), which comes in a spray can and contains UV protection.

drawing &
resists with
acrylic

THIS CHAPTER IS A RIFF ON DRAWING

and the idea of line. It's about using paint to make lines

by squirting, drizzling, splashing and flinging, using tools to

change a line, and creating a crazy number of acrylic sur-

faces to make marks on with traditional drawing materials.

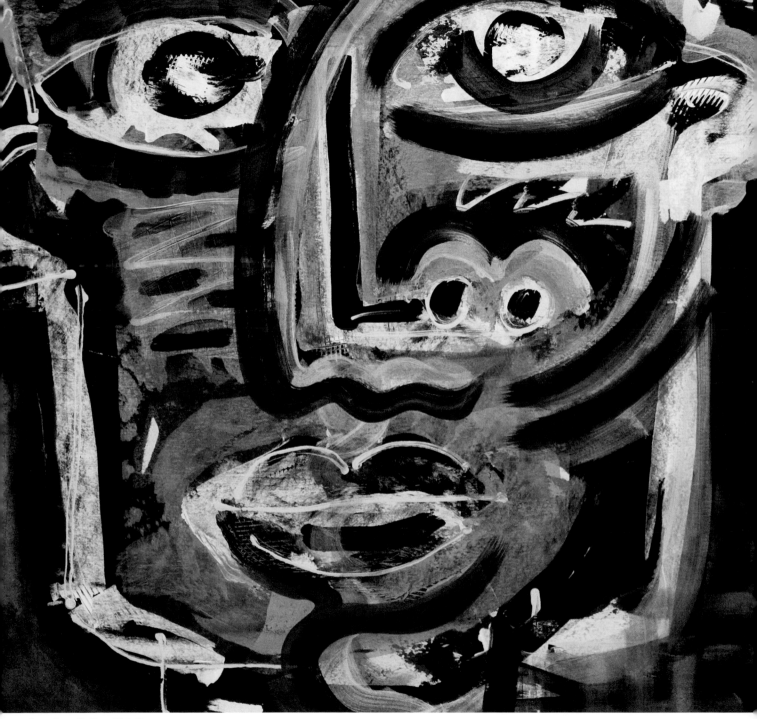

Cacophonetic Face (Detail)
Merle Rosen
Acrylic on watercolor paper

clear tar gel

Clear Tar Gel's resinlike quality is perfect for dripping off a tool to create a line. By moving the tool quickly across the surface, you can create a fine line; if you move it slowly, the line will be thicker.

When adding fluid or Airbrush colors to Clear Tar Gel, add small amounts and stir well. Adding too much color will defeat the stringy quality of the gel. Vigorous stirring will create foam, so before dripping or pouring, allow the mixture to sit overnight.

drizzling a line
Clear Tar Gel drips off a palette knife, creating a fine, Jackson Pollock-like line. Lines previously dripped were tinted with small amounts of fluid color.

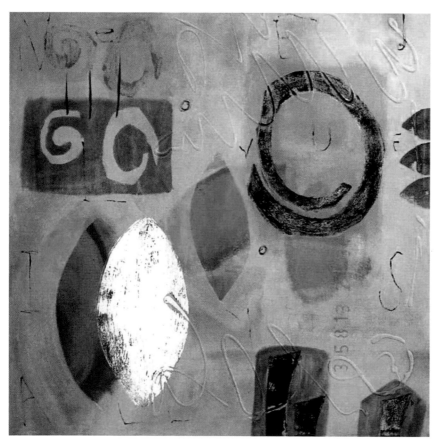

clear tar gel resists
Tesia Blackburn began this painting by drizzling a line with Clear Tar Gel using a looping, circular movement. The prominent line intrudes on all the subsequent applications. The Matte fluids give her surface a very flat, gouache-like look. The bold shapes are made with a technique called decalcomania. She used cutout paper shapes, that were painted with wet Matte fluids to transfer the paint directly onto the surface of the canvas. The Clear Tar Gel lines are visible where the paint is resisted because of the raised line.

All You Need Is Love
Tesia Blackburn
Acrylic on canvas
24" × 24" (61cm × 61cm)
Photograph courtesy of Almac Camera, SF CA

applying lines for resists

The art on this page shows how a clear glossy medium can be squeezed to draw a line that will be revealed only when a wash is applied.

When working with this technique, plan ahead to choose the layers of color you want to see when the work is finished. Play with alternating layers of gloss and matte paints or gels, flat areas and raised lines, with colored washes or stains sandwiched in between. Instead of using a light-value absorbent ground, try using a dark ground with washes in light-value colors.

There are many different tools for applying a line with paint. Craft and hobby stores have various applicator tips and refillable bottles. Cake decorating tips also offer a variety of sculptural options.

creating a glossy line
I'm using a squeeze bottle filled with Polymer Medium (Gloss) with a pointed tip to extrude the medium over a surface of Coarse Molding Paste. This will create a glossy line on a matte surface. Draw the entire image with the squeeze bottle, using the tip as your drawing tool. The wet Polymer Medium (Gloss) is easy to see because it's white but when it dries, the line drawing will be completely clear.

revealing the line
A thinned wash of Prussian Blue Hue and Micaceous Iron Oxide is painted over the dampened surface. The high gloss lines immediately repel the dark wash, while the porous surface of the Coarse Molding Paste soaks up the color.

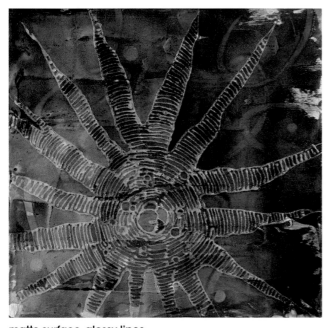

matte surface, glossy lines
This example shows how the glossy pattern remains distinct from the matte surface, adding to the illusion of depth.

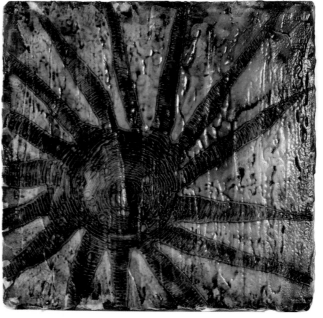

matte lines, glossy surface
For a glossy surface, I applied Clear Tar Gel over tinted Coarse Molding Paste, and used Matte Medium for the line drawing. Even with the same wash of Prussian Blue Hue, the look is entirely different.

examples of line resists

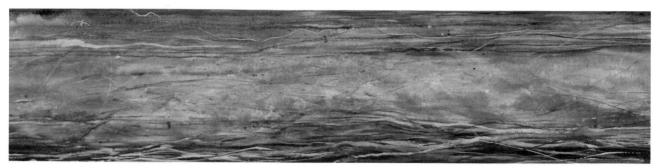

playing with resists and washes

Barbara Jackson is a master at playing with resists and washes. The rich color, stains and washes create an intriguing depth against the poured gel lines. Barbara used multiple layers of fluid acrylics and tinted Clear Tar Gel over Absorbent Ground.

Night Trains Passing
Barbara Jackson
Acrylic on canvas
10" × 48" (25cm × 122cm)

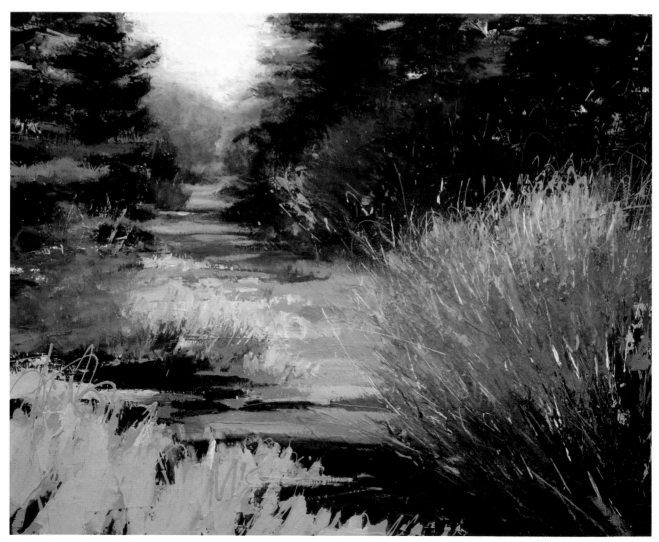

dynamic paint applications

In this example, you can see a variety of energetic applications. Mary Morrison has created lines with fluid acrylics flung off a palette knife, and dripped, splashed and drawn from a fluid bottle.

Trailhead
Mary Morrison
Acrylic on panel
38" × 46" (97cm × 117cm)

acrylic as drawing medium and surface

Here artist Corrine Loomis-Dietz shows us how to create an acrylic drawing that can become a unique drawing surface for other mediums.

options for creating a clear acrylic skin

In addition to Polymer Medium (Gloss), you can use GAC 500, GAC 800 or Self Leveling Clear Gel to create transparent acrylic skins. All of these mediums dry clear. Lightly mist these surfaces with rubbing alcohol if they form air bubbles.

1 trace the image onto a glass plate

Place a photocopied image or print under a glass plate. Using a bottle of Iridescent Copper (Fine), trace the image onto the glass, creating a continuous line around the subject. Let the paint dry.

2 add polymer medium (gloss)

Fill in the areas between the lines of Iridescent Copper (Fine) by carefully pouring Polymer Medium (Gloss) into each space, creating a pool of the medium. Lightly mist the surface with rubbing alcohol to eliminate the air bubbles and let it dry. Carefully remove the skin from the glass and place it on a white surface.

3 add tooth to the acrylic skin

Thin 8 parts Acrylic Ground for Pastels with 2 parts water. Brush a thin layer of this over the skin's surface with a 1½-inch (38mm) flat house-painting brush to add tooth to the acrylic skin. Let this dry then apply another coat. Use a colour shaper to remove any Acrylic Ground for Pastels from the surface of the Iridescent Copper and let the second coat dry.

4 add color and detail

Add color and detail to the acrylic skin drawing with a selection of soft pastel pencils. The tooth added by the Acrylic Ground for Pastels is perfect for pastels, colored pencils, or washes of fluid acrylics.

the next move is yours

The resulting image is a fun, flexible skin that can be used as an independent art piece or as a collage element of a drawing or painting. Notice that the skin is still transparent. You can see Corrine's fingers behind the head.

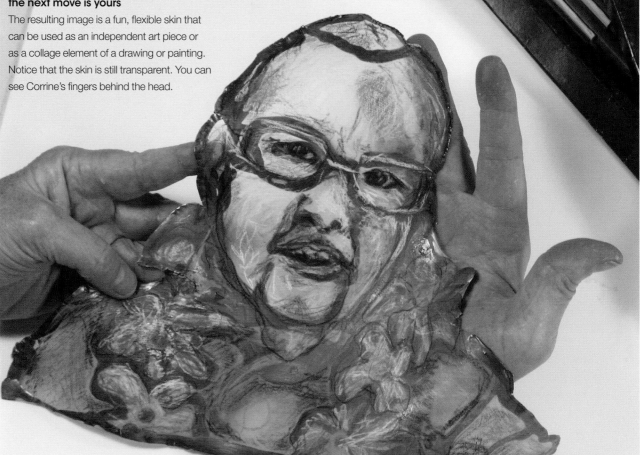

painting over an acrylic surface

Here artist Corrine Loomis-Dietz uses direct transfers and acrylic skins to develop the concept of connections and crossroads. The top portion of this painting was created from a direct transfer made with Fine Pumice Gel, painted over with fluid acrylics that were extended with Acrylic Glazing Liquid. The map portion of the piece is an acrylic skin made with Soft Gel (Gloss) and coated with Matte Medium. The Matte Medium produced a surface that would accept other fluid acrylics extended with Soft Gel (Gloss).

Standing in Place
Corrine Loomis-Dietz
Acrylic on canvas
16" × 16¼" (41cm × 42cm)

drawing on acrylic grounds

Many acrylic grounds will create a surface suitable for traditional drawing mediums such as charcoal, graphite, colored pencil and pastel. You can use different gels to customize the tooth, exploiting a range of textures from the subtlety of Fine Pumice Gel to the chunky grit of Coarse Pumice Gel. Acrylic grounds allow you to get around the limitations of paper, creating surfaces that can handle the water used with water-soluble pencils or provide the clean white ground necessary for silver point. You can apply an acrylic ground to your choice of substrate, be it wood, canvas or even a wall. You can tint the ground with your choice of color. You can make your surface as large as you want—as long as it will get through your studio door or fit in your truck. Here are some ideas to get you started.

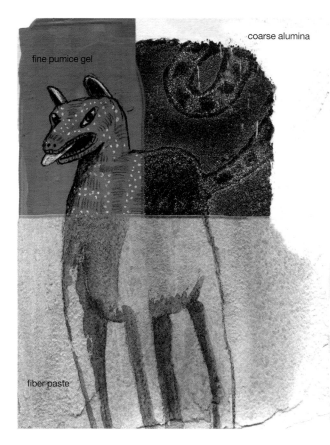

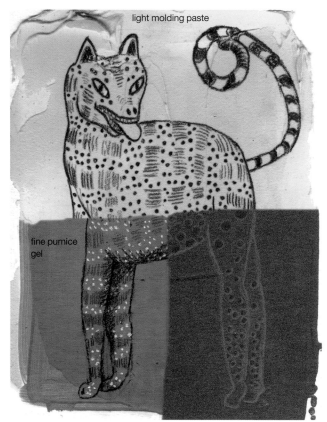

drawing with charcoal, graphite and colored pencil

··· Fine Pumice Gel is tinted with Fluid Cobalt Teal and Titan Buff and drawn over with black and white charcoal and blue colored pencil.

··· Coarse Alumina is tinted with Cobalt Blue and a wash of Titanium White is applied over that, which helps the white charcoal stand out.

··· Fiber Paste with a Terre Verte Hue wash over it. The drawing is done with a water-soluble graphite pencil.

drawing with charcoal and colored pencils

··· Light Molding Paste is tinted with Green Gold over which charcoal pencil is used.

··· Fine Pumice Gel is tinted with Fluid Cobalt Teal and Titan Buff and drawn over with black and white charcoal and blue colored pencil.

··· Micaceous Iron Oxide is tinted with Interference Green and drawn over with pink colored pencils.

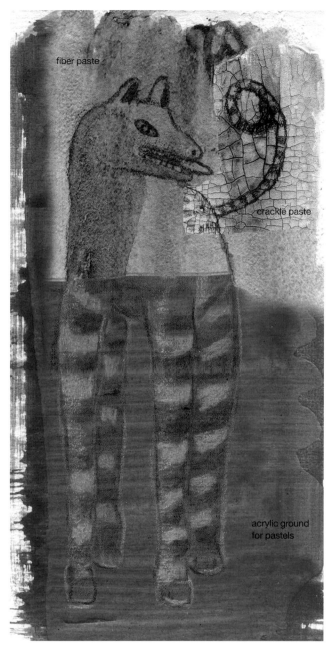

fiber paste

crackle paste

acrylic ground
for pastels

drawing with graphite, colored pencil and water-soluble colored pencil

··· Fiber Paste is washed with Heavy Body Terre Verte Hue and drawn over with water-soluble graphite pencil.

··· Crackle Paste is layered with a wash of Smalt Hue mixed with Cobalt Teal over which a graphite pencil is used.

··· Acrylic Ground for Pastels is tinted with Vat Orange and applied over a basecoat of Diarylide Yellow. Over this, colored pencils and water-soluble colored pencils are used.

coarse alumina

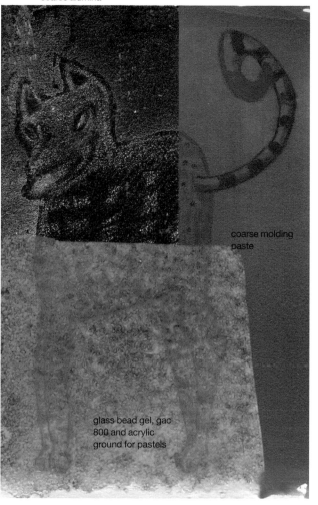

coarse molding paste

glass bead gel, gac 800 and acrylic ground for pastels

drawing with colored pencils, soft pastel and charcoal pencil

··· Coarse Alumina is tinted with Fluid Cobalt Blue and drawn over with white charcoal pencil.

··· Coarse Molding Paste is tinted with Red Oxide. Colored pencils serve as the drawing medium.

··· Glass Bead Gel is layered with a wash of Anthraquinone Blue, then a wash of Indian Yellow Hue. GAC 800 is poured over the surface to level it out, then a thin coat of Acrylic Ground for Pastels is applied over that. Over this, blue soft pastel is used to complete the dog's figure.

Merle Rosen

I love most all art supplies and processes. That said, I have always enjoyed the drawing process more than painting because of the immediacy of mark-making. I have a strong affinity for drawing and the many ways that process can be applied to acrylic products. The many possible surfaces one can achieve with gels, grounds and paint viscosities have me constantly experimenting with different combinations of surfaces and application techniques. Acrylic allows me to use an incredibly wide range of applications to achieve spontaneity within this diverse medium.

Artist Merle Rosen at work in her studio

One of my objectives is to keep a relaxed and impromptu energy going through the entire painting process; therefore, no matter what tool I am holding, I use it with both the deliberation and speed inherent in the drawing process. In other words, whether I am holding a small line brush, a graphite pencil or a 6-inch (15cm) squeegee, my movements on the support surface are energetic, informal and confident.

Cacophonetic Face
Merle Rosen
Acrylic on watercolor paper
30" × 22" (76cm × 56cm)

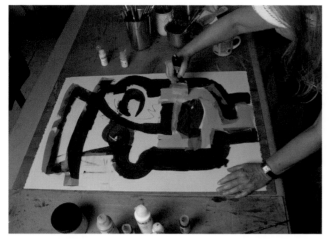

applying the colors

I start my drawing with the tip of a bottle of fluid acrylics on a sheet of 140-lb. (300gsm) gray Stonehenge rag paper. I squirt on more fluid acrylics, then use a squeegee to scrape them into the negative shapes created by the initial image. I use contrasting colors so the "drawing" underneath is still visible. As the painting develops, the base layers will overlap.

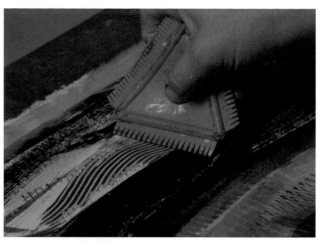

adding various textures

I'll add a retarding agent such as Acrylic Glazing Liquid to give me a longer open time so I can scrape through lines with tools such as notched scrapers, sticks or miscellaneous recycled objects. Acrylic Glazing Liquid also can be used to create a glaze, depending on how much you add. Slowing the drying process allowed me to experiment with a variety of effects.

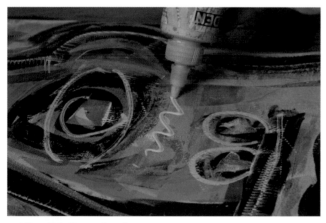

adding thin lines of color

Essentially I'm starting with thin lines of squirted paint and then squee-geeing these into very broad, flat planes of color. The lines get progressively thinner as I apply different colors. When I use a squeegee, the paint is spread so thinly and dries so quickly that I can work continuously, adding layers without having to wait for previous layers to dry, as I would if I were applying heavier layers of paints or gels.

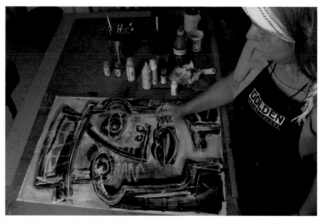

brushing on final touches

I add final lines with a pointed applicator or a brush. This kind of painting can be done in a single sitting. I don't even need a palette because I can apply the paint directly onto the paper support.

traditional
techniques
with acrylic

WHILE ACRYLIC WILL NEVER GIVE OFF

the romantic aroma of oil and turpentine, it certainly can

be used for the techniques usually associated only with

oil painting. Acrylic won't replace oil, but it has found its

way into many studios. Advances have propelled acrylic

into the hands of many traditionalists, thanks to longer

open times and hues that are similar to those of oil paint.

Acrylic artists can now achieve the luscious, rich color

and smooth blending of oils to create new works with a

classic look.

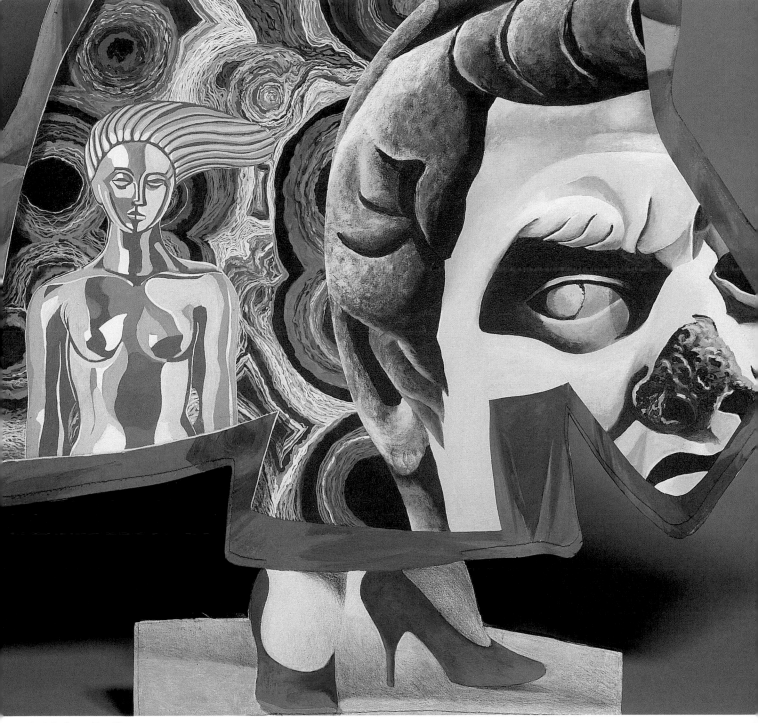

Lady in Green (Detail)
Dianne Bugash
Acrylic on canvas over Gator board

old masters' palette

Historical Colors are re-creations of paint colors that were traditionally available only in oil or watercolor paints. These colors have been in use for hundreds of years, and were considered essential to the working palettes of past masters. Historical hues in acrylic form combine the visual characteristics of their original pigments with the advantages of acrylic, including reduced toxicity, increased lightfastness and greater permanence. Artists who wish to explore a more traditional look will find these new hues typical of the Old Masters' palette.

hue

The term *hue* has two different meanings when describing paint and color. It's the name of a color in its pure state; for example, red is a hue. When the term *hue* is used in a paint name, it means that the paint simulates the color of the original pigment. For instance, Cadmium Yellow Hue doesn't contain any cadmium pigment, but is a blend of other colors. For artists, the *hue* designation provide safer, more economical alternatives to the original pigments.

old masters' surface

Oil paintings typically were finished with damar varnish to consolidate the surface and add a glossy sheen. Varnishing an acrylic painting with a gloss varnish will provide a similar finish.

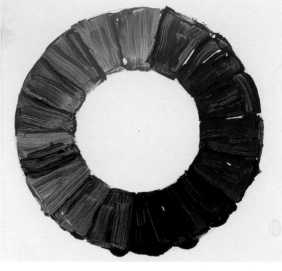

transparent triad
This palette consists of OPEN acrylic colors Indian Yellow Hue, Alizarin Crimson Hue and Manganese Blue Hue. Indian Yellow Hue is a translucent yellow great for rich mixed greens and warm oranges. The brilliance of Manganese Blue Hue lends itself well to cool, soft mixtures.

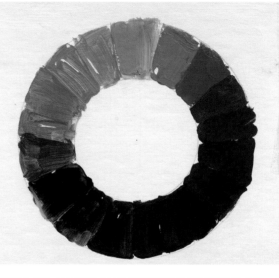

semi-transparent triad
Heavy body Aureolin Hue and Smalt Hue, plus OPEN color Alizarin Crimson Hue make up this triad. Aureolin Hue is an earthy but bright mixing color and mixed with Smalt Hue yields a range of olive greens.

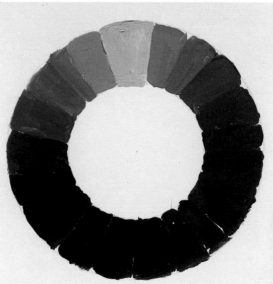

opaque triad
This triad consists of OPEN Naples Yellow Hue, OPEN Alizarin Crimson Hue and Heavy Body Prussian Blue Hue. Naples Yellow Hue mixed with Alizarin Crimson Hue creates beautiful rosy pinks. The yellow mixed with Prussian Blue Hue makes gray greens while the mixed violets are dark and ruby-toned.

grisaille

Many artists who want to paint with traditional methods have learned to work around acrylic's quick drying time for smooth blending techniques. For others who struggle with the drying time, a new formulation of paint, called OPEN acrylics, provides a longer, more relaxed working time for seamless blending. Its lower viscosity lends itself to a smoother surface with less visible brushstrokes.

OPEN acrylics work well for the Old Masters' technique of creating a grisaille underpainting (see page 120). It's best to mix the grays ahead of time on your palette. Once all the values are laid in place, you can carefully blend them together. Using OPEN acrylics allows you to blend the colors without worrying about them drying too fast.

materials

FLUID ACRYLICS
Alizarin Crimson Hue, Manganese Blue Hue, Yellow Ochre

OPEN ACRYLICS
Cadmium Red Medium, Cadmium Yellow Medium, Carbon Black, Cerulean Blue, Dioxazine Purple, Naples Yellow Hue, Quinacridone/Nickel Azo Gold, Raw Sienna, Raw Umber, Titanium White, Ultramarine Blue

TOOLS
¼-inch (6mm) synthetic fan brush, ¼-inch (6mm) synthetic filbert brush

SURFACE
Stretched canvas

OTHER
OPEN Thinner, Polymer Medium (Gloss)

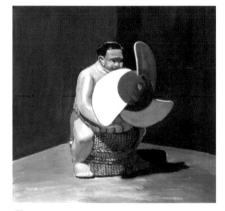

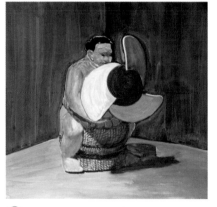

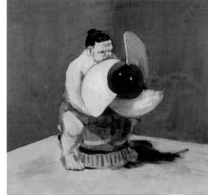

1 establish the grisaille

Paint the grisaille with OPEN acrylics since their long open time allows you to subtly blend the colors and work until you've mastered the underpainting. Work in thin applications and make sure the surface is "touch dry" before moving on.

2 add fluid acrylics

Over the grisaille apply numerous glazes of fluid acrylics mixed with Polymer Medium (Gloss). Since fluid acrylics dry quickly, you can apply several glazes in a short amount of time. Notice how the shadows and highlights of the grisaille filter through these glazes.

3 finish with OPEN acrylics

Apply opaque layers of OPEN acrylics. Blend carefully and smoothly using a small synthetic fan brush. If the colors become too muddy, scrape the color off and apply new color.

additional glazing options

Slow-drying glazes are helpful if you're blending multiple colors on the surface. Here are some tips for getting a smooth brushless glaze:

··· For maximum working time, use OPEN acrylics thinned with the OPEN Thinner (add a maximum of 1 part thinner to 3 parts paint), or mix OPEN acrylics with OPEN Acrylic Medium (Gloss). If you want the glaze to dry quickly, use fluid acrylics mixed with OPEN Acrylic Medium (Gloss). It's imperative this product be used for thin layers. Layers more than 1/16-inch (1½mm) will dry very slowly and remain tacky for extended periods of time.

··· Retarder also can be used in very thin applications to produce a very flat, brushless application. Retarder is not a binder, so use a maximum of 3 parts retarder to 17 parts paint.

··· Acrylic Glazing Liquid mixed with fluid acrylics allows for a choice of gloss or satin finishes. Acrylic Glazing Liquid can either be used on your palette or mixed into paint.

··· Try using Airbrush Transparent Extender. It has the viscosity of water, so it can create a very thin glaze with little visible brushstroke. Airbrush Transparent Extender is designed to not clog or dry in the small openings of an airbrush, so it will keep a thin glaze open longer.

multiple transparent layers
The deep color of the water was created with countless transparent glazes made with OPEN acrylics and OPEN Acrylic Medium (Gloss) over an imprimatura of bright red. The turquoise water lilies are blended heavy body acrylics thickened with Heavy Gel. Acrylic Glazing Liquid was added to create enough open time to blend the color. The oil-like quality of this painting is enhanced by a layer of MSA Varnish (Satin).

Memento/Lake at Ryoanji II
Phillip Garrett
Acrylic on linen
26" × 40" (66cm × 102cm)

blending with open acrylics

Values that range from light to dark add depth to your image. Artist Dianne Bugash demonstrates how blending these values can create the illusion of volume. Smooth, gentle transitions from one value to another simulate techniques traditionally accomplished with oil paint.

materials

FLUID ACRYLICS
Permanent Green Light

HEAVY BODY ACRYLICS
Hansa Yellow Light, Mars Black

OPEN ACRYLICS
Cerulean Blue (Chromium), Jenkins Green, Phthalo Green (Blue Shade), Titanium White, Yellow Ochre

TOOLS
½-inch (12mm) synthetic filbert brush, pencil

SURFACE
Canvas primed with gesso

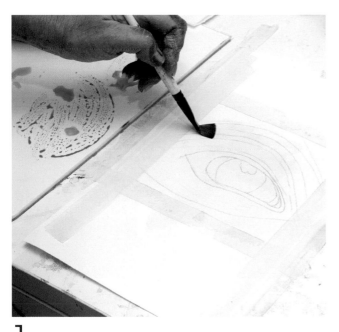

1 sketch the subject and start building layers
With a pencil, draw the image onto the canvas. Wash thinned Permanent Green Light over the drawing with the ½-inch (12mm) filbert.

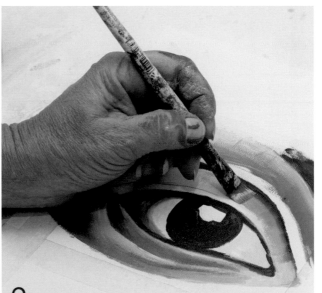

2 establish the location of different values
As you lay down each value next to another, wipe your brush clean between applications. With the clean brush, stroke one wet color into the other. Without overloading your brush with paint, apply enough color to cover the canvas smoothly.

139

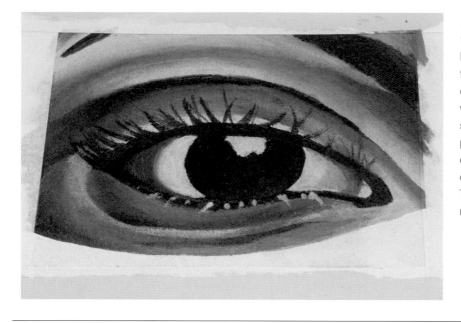

3 rework until you're satisfied

Rework your image until you are satisfied with its appearance. If you want to change the look of a part of the piece while it's wet, add a bit more color to the surface and blend it into the rest of the paint. OPEN acrylics can be carefully overpainted before drying without lifting or mixing with the color underneath. This allows you to adjust any areas that need it.

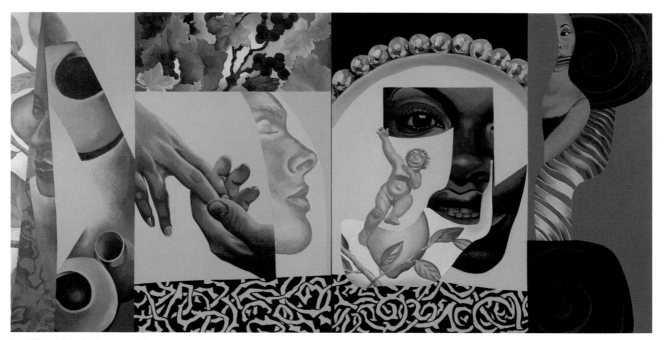

traditional technique, modern application
Several areas in this painting use monochromatic color blends: the purple hands, the orange profile of a face and the green face surrounded by the bright blue.

Womansphere
Dianne Bugash
Acrylic on canvas
48" × 96" (122cm × 244cm)

scumbling

Scumbling is like drawing; you use very little paint on a dry brush and softly scrub it onto an underpainting. Dianne Bugash demonstrates this technique using heavy body paint. The thin, scumbled layers of heavy body acrylic will dry quickly and won't blend into the first layer.

materials

HEAVY BODY ACRYLICS
Cadmium Yellow Medium, Jenkins Green, Pyrrole Red, Sap Green Hue, Titanium White

TOOLS
½-inch (12mm) synthetic filbert brush, pencil

SURFACE
Paper over board

OTHER
GAC 100, gesso

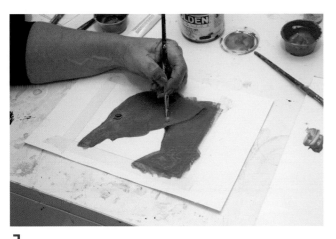

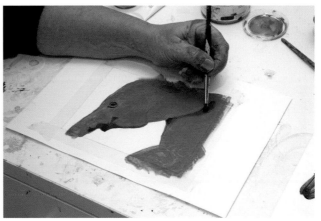

1 paint the initial shape and add details

Mix Pyrrole Red, Cadmium Yellow Medium and Titanium White and use this to create an underpainting of your shape with a ½-inch (12mm) filbert. Pencil in the outline of the head, shadows, highlights and inner ear. Pick up very little paint on a dry ½-inch (12mm) filbert and lightly scrub in the green paint, following your guidelines. Add medium greens to the shadow areas.

2 scumble in the darks

Scrub in darker greens into areas of shadow with a ½-inch (12mm) filbert. For the darkest shadows, scumble more darks until you feel that area recedes accordingly.

3 add lights and highlights

When you are satisfied with the layers of darks, you can scumble in lights or highlights in any area with an orange color.

combining different types of acrylic

You can customize the drying time of acrylic paints by combining OPEN acrylics with heavy body or fluid acrylics.

materials

FLUID ACRYLICS
Diarylide Yellow, Dioxazine Purple, Green Gold, Pyrrole Orange, Raw Umber, Titanium White

HEAVY BODY ACRYLICS
Cadmium Red Light, Cadmium Yellow Light, Dioxazine Purple, Green Gold, Raw Umber, Titan Buff, Titanium White, Ultramarine Blue

MATTE FLUID ACRYLICS
Pyrrole Red

OPEN ACRYLICS
Diarylide Yellow, Dioxazine Purple, Green Gold, Raw Umber, Titanium White

TOOLS
¼-inch (6mm) synthetic filbert brush, ¼-inch (6mm) synthetic fan brush

SURFACE
Wood panel

OTHER
GAC 100, gesso, OPEN Acrylic Medium (Gloss)

1 establish the basecoat and underpainting

Create a Pyrrole Red imprimatura with a filbert. Thin matte fluid acrylics with water and quickly lay in the shapes, working out the color scheme. Fluids are a good choice here since they dry quickly and show few brushstrokes. Let this dry.

2 blend with OPEN acrylics

Apply a layer of OPEN acrylics, so that you can take your time blending the colors and making adjustments. Rework areas of OPEN acrylics that are "touch dry" by using OPEN Thinner or OPEN Acrylic Medium (Gloss). Let this dry.

3 add texture with heavy body acrylics

Use heavy body paints to add texture and drybrush effects. Since heavy body acrylics dry quickly and retain brushstrokes, they are an ideal choice here.

examples of traditional techniques

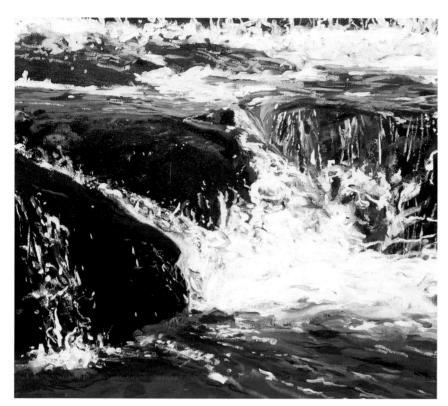

thick, defined brushstrokes

The turbulent water cascading over the rocks is achieved with a thickened mixture of Extra Heavy Gel (Matte) and High Solid Gel (Matte) and (Gloss). This allows the artist to achieve thick, well-defined brushstrokes, which are enhanced by a final glaze of Micaceous Iron Oxide. The painting is finished with MSA Varnish (Satin).

Falls on the Reedy II
Phillip Garrett
Acrylic on linen
36" × 36" (91cm × 91cm)

modern paints, traditional method

Ferdinands achieves the oil-like look with acrylic by choosing a traditional palette of color and using heavy body paints and Acrylic Glazing Liquid. Her mastery of painting techniques covers blending, modeling and glazes. I love the combination of modern materials and traditional techniques, and the play with historical paintings against modern ideas.

Seduction
Frances Ferdinands
Acrylic on canvas
36" × 73" (91cm × 180cm)

Dianne Bugash

In 1990, I had finished a series of abstract paintings exploring visual relationships, which led to thinking about relationships in general. I realized that relationships were visual, physical, emotional. I decided that I wanted to paint imagery that cut away extraneous information and got to the core of something I didn't understand yet; thus, the cutouts were born.

Lady in Green is part of a series of paintings exploring the dichotomy of who we are to the public versus who we are inside. This painting addresses the issue of women and glamour. Lady in Green, dressed in a gown, elegantly coifed and powdered, performs for her audience. She is there in body, but her soul has left the room.

Artist Dianne Bugash, surrounded by cutouts in her studio

I made *Lady in Green* with medium-texture, cotton-duck canvas, glued with acrylic gel onto ¾-inch (19mm) birch plywood. Once dry, her shape was cut out with a jigsaw and the canvas was given three coats of gesso. I used an angle iron to stand and weigh down the cutout, which was bolted to the back of the painting.

Lady in Green
Dianne Bugash
Acrylic on canvas over Gator board
75" × 40" (190cm × 102cm)

my studio

Here you can see inspirational notes and images from others, notes to myself and art materials ready to go. To be my most creative self in my studio, I always have paints and brushes on hand, as well as miscellaneous materials such as journals, drawers of saved images, pieces of collaged imagery, stamps, stencils, drawings, and books about my most favorite artists. As I prepare to do an artwork, I can research, pull imagery, edit and solve problems from vast resources.

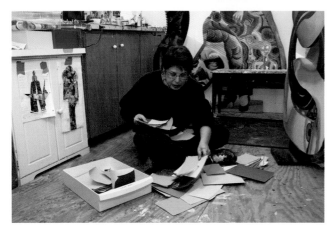

selecting a color palette

Sometimes my color palette for a new painting is not apparent to me, or I need to work out color combinations for different areas of a painting. Color Aid papers help me decide the color values, relationships and mood I want to portray. As I begin thinking about a painting, it's very important for me to have specific imagery in mind and follow my own personal sense of rhythm, style and balance.

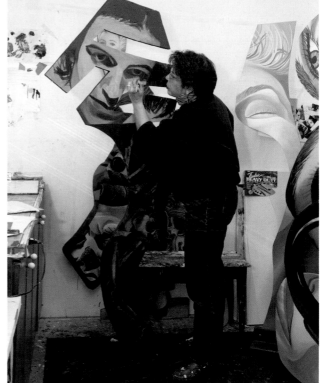

painting once preparations are complete

After I'm satisfied with a drawing, I begin painting. I mix basic colors first. From there I find the in-between variations of color that come with spontaneous mixing.

varnishing

THIS FINAL CHAPTER DESCRIBES HOW TWO professional artists, Phil Garrett and Roy Kinzer, add the finishing touch to their acrylic paintings. Each has a very clear aesthetic for the final finish of their work. Both painters know that they will be varnishing, and thus go to great lengths to prepare their surfaces correctly.

Although I appreciate the beautiful finishes that Phil and Roy achieve, my choice as an artist is not to varnish. I certainly recognize the reasons for a varnish, but the surfaces of my paintings are riddled with strong contrasts between flat, velvety satins and glasslike glosses, and any application of varnish would simply negate the effects that I work to achieve. From here, Phil Garrett takes over this chapter, as he has truly mastered the "art" of varnishing.

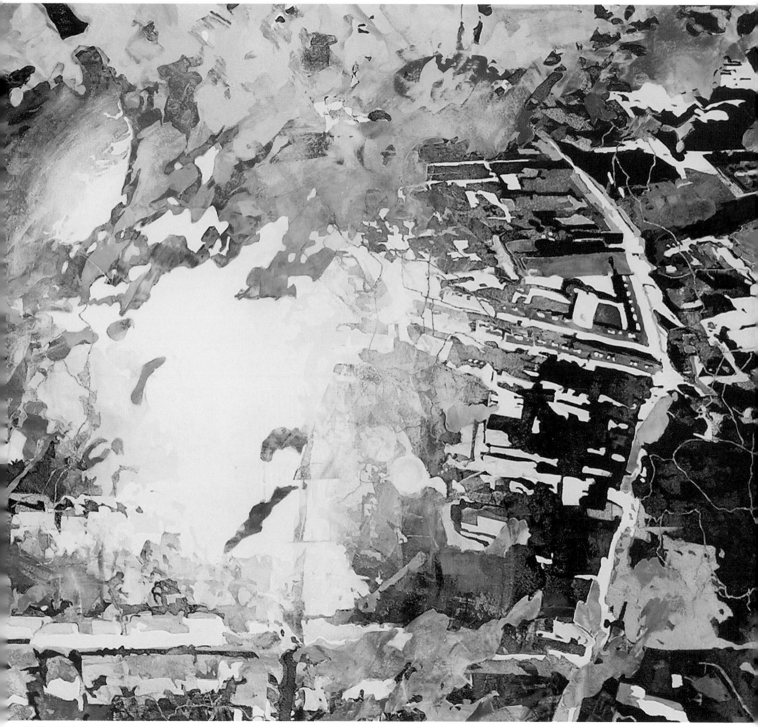

Kothen (Detail)
Roy Kinzer
Acrylic and collage on wood panel
Courtesy of the artist and Denise Bibro Fine Art, New York

why varnish

Varnishing serves the practical purpose of protecting the painting as well as the aesthetic function of unifying the elements on the surface. Varnishes are highly recommended for acrylic surfaces because the paint can soften in warm air and harden in cold. In addition, varnish will protect the surface from dirt and dust. If you're varnishing a piece painted with fluid or heavy body acrylics, wait one to three weeks before varnishing. If you're working with OPEN acrylics, wait at least thirty days before varnishing.

It's best to use a varnish with ultraviolet light stabilizers (UVLS), which protect the pigments in the paint from fading or darkening. It's also important to know that putting a coat of Polymer Medium (Gloss) over a finished painting is not a varnish; it's a topcoat. This basically means the polymer becomes part of the paint film and is neither removable nor reversible.

Depending on the varnish finish you use (gloss, satin or matte), the varnish will unify the surface of the finished painting, muting otherwise glossy surfaces or making matte surfaces shinier.

selecting an acrylic varnish

Several attributes are essential for a varnish to be considered for professional use:

··· Removability

··· Flexibility

··· Lack of tackiness

··· Resistance to discoloration

··· Clarity

practice makes perfect

It's very important to experiment with varnishes on test pieces or failed paintings before using them on finished works so you can see how they perform and how they alter the appearance of your paintings. For best results, apply the varnish to a test piece that is similar to the artwork to be varnished. Take the time to read all the literature about the proper way to varnish, aesthetic options and removal techniques. It takes skill and practice to do it well. Good preparation will help ensure that all variables are accounted for and a successful varnish application will be achieved.

equipment for varnishing acrylic paintings

prepare an isolation coat

Use isolation coats only for acrylic paintings, not for oil painting. An isolation coat is a protective, permanent layer that provides a buffer between the painting and the varnish, making it the first step in the varnishing process. When the varnish is removed, the isolation coat will keep the painting underneath from being disturbed. Isolation coats also seal highly absorbent surfaces. This uniform surface allows for an even coat of varnish to be applied. You can either brush or spray on an isolation coat.

isolation coat formula for brush application

If you want to brush on the isolation coat, mix 2 parts Soft Gel (Gloss) with 1 part water. (This mixture is white when wet, but dries to a clear gloss.) Stir the mixture well and allow it to sit for twenty-four hours so that any foam created by mixing will dissipate. For nonabsorbent surfaces, only one coat of the formula will suffice. More absorbent surfaces may require up to three coats.

isolation coat formula for spray application

To spray on an isolation coat, mix 2 parts GAC 500 with 1 part Transparent Airbrush Extender. GAC 500 forms a very clear, durable film, while the extender helps the mixture flow through an airbrush or spray gun with minimal clogging.

mixing a brush applied isolation coat
Here, I'm mixing water into Soft Gel (Gloss). Its low propensity for creating foam makes it the perfect choice for thinning with water.

mixing an isolation coat for spray application
Mixing GAC 500 with Transparent Airbrush Extender which will be used in a sprayer with a trigger attached. Remember to mix the formula in a clear container.

exercise caution when spraying an isolation coat

Spraying paint materials calls for protection from the vaporized materials. Wear a respirator and protective glasses or goggles even when spraying outdoors. Make sure your other paintings and works in progress are protected from the overspray.

choosing a varnish formula

The amount of surface variation and the degree of roughness in its texture determine which isolation coat formula you use. If your surface is rough or has several thick layers, spraying will give you better coverage. If the surface is already fairly even and smooth, use a brush. For paintings with OPEN acrylics, wait at least two weeks before applying an isolation coat.

preparing msa varnish

There are many varnishing products available for acrylics. The varnish I use consistently is Golden's MSA (Mineral Spirit Acrylic) Varnish with UVLS, which comes in matte, satin and gloss finishes. Experiment with different brands to see which you prefer. MSA Varnish is very thick and needs to be thinned with full strength mineral spirits. Mix 1 part solvent with 3 parts gloss varnish in a clear glass container. Stir continuously until the mixture is crystal clear. If the mixture stays cloudy, the solvent isn't correct. I've found Stoddard solvent, a high-grade mineral spirit, works very well for this purpose.

varnishing tips

··· Use a clear glass jar to prepare your varnish mixture.

··· A mixture of 1 part solvent to 3 parts MSA Varnish works well if you prefer to brush on the varnish. Thin the formula by adding solvent in small increments and stirring until the consistency suits you.

··· Make a fresh batch of varnish each time you varnish a painting.

··· Save time by varnishing several paintings at the same time. This also will limit your exposure to the solvent.

··· Use a high-quality synthetic brush to apply the varnish. Store the brush in a covered container with the bristles covered up to the ferrule in the solvent used to thin the varnish. This allows you to pull out the brush, wipe off the solvent, and use it with a minimum of cleanup or fuss.

··· Varnish on a flat, level work table that allows you easy access to all sides of the painting. Give yourself plenty of room for varnish jars and to see exactly where your strokes of varnish are. Good overhead lighting is critical.

··· Load the brush with varnish and let it flow as you work. Keep your strokes parallel, slightly overlapping each preceding stroke until the painting is covered with varnish. MSA Varnish self-levels very well. When one layer is dry, apply the next coat at a right angle, as though weaving a textile.

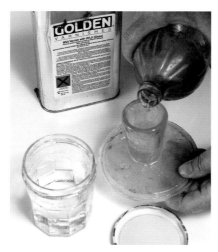

mixing the varnish
Mixing MSA Varnish in clear glass containers will show you if the mixture is clear.

getting the appropriate mixture
The mixture should be crystal clear. If the mixture stays cloudy, you must re-mix another batch of formula.

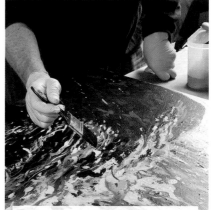

brushing on the varnish
Here, I'm brushing the varnish over a dry isolation coat. Notice the plastic container that serves to store the brush. I use several layers of varnish and always use MSA Varnish (Gloss) for the first or second undercoats, followed by a coat of MSA Varnish (Satin) for a final coat with a softer sheen.

archival spray varnish

For smaller paintings or studies, I sometimes use Archival Spray Varnish with UVLS. I recommend placing a trigger assembly (available at paint and hardware stores) over the button. This will give you better control of the spray and will help keep the angle of the spray parallel for an even coating. Spray the layers over the isolation coat in the same way as you would the brushed layers. Spray coats dry much quicker than brushed coats. They are also much thinner, so you'll need more coats, but they will provide excellent protection for the painting.

Once you've finished varnishing, let the varnish cure at least a week before handling or shipping.

removing the varnish

Hopefully, your painting will never be damaged in a fire, or displayed where dirt and dust will eventually create a visual barrier to enjoying the image. Professional varnishes are designed to be removable to safeguard the original works.

Before embarking on a varnish removal mission, carefully consider the materials and how they can be used in a safe, controlled manner. Varnish removal requires the use of solvents, which in turn, require using proper personal protective equipment, including an appropriate respirator, impervious gloves, aprons, goggles and adequate ventilation.

MSA Varnish is removable with mineral spirits. Research varnish removal techniques and practice on a sample or a failed piece before attempting removal on a finished painting.

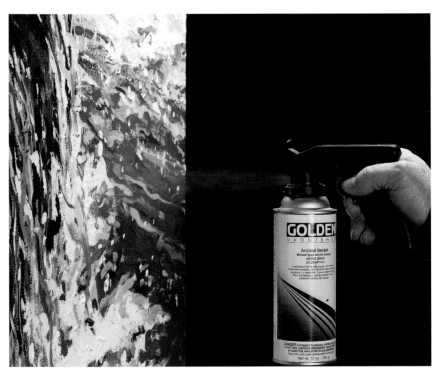

using spray varnish

When spraying varnish, wear a respirator and protective eyewear and use a setup that will protect your other paintings or objects from the overspray. Set up the painting on an easel, making sure you have enough room to start spraying ahead of the painting and finish the stroke beyond the edge of the painting. Keep your body and the spray as parallel to the surface as you can, overlapping the strokes each time. Each coat should be at a right angle to the previous one. The easiest way to do this is to turn the painting to the right before each coat.

varnishing water-soluble mediums

Watercolor and other water-based mediums can be reactivated with water, including an isolation coat. If you want to apply an isolation coat, use the spray formula (page 149) with a very light mist. Try this on a test piece first to see if any blurring occurs. Then proceed with the isolation coat, then the varnish layer.

Solvent-based varnishes can be applied directly over water-based mediums since these varnishes do not contain water. If you choose not to apply an isolation coat, you will not be able to remove the varnish at a later date. However, you will get the UVLS protection and seal against any water sensitivity.

examples of varnished pieces

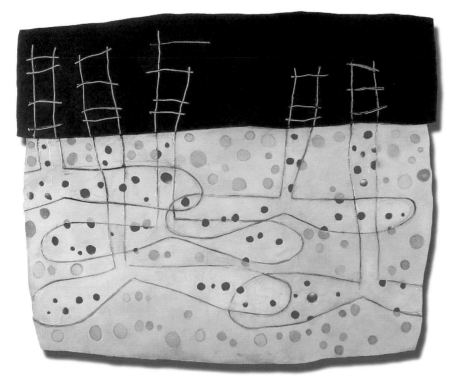

varnish provides protection

Many of artist Declan Halpin's paintings are purchased for corporate locations and are installed in high-traffic areas or in lobbies with exposure to direct sunlight. Varnishing is essential for the protection of the painted surface.

Viral
Declan Halpin
Acrylic and mixed media on aluminum
47" × 53" × 3" (119cm × 135cm × 8cm)

keeping light-sensitive materials safe

Artist Jaq Chartier used a matte MSA Varnish with UVLS with a touch of satin to alter the sheen and to protect the surface. The removable varnish layer has saved more than one piece from permanent damage. And the UVLS protection is a great bonus, since some of the materials are light sensitive.

6 Lanes
Jaq Chartier
Acrylic, stains and spray paint on wood panel
11" × 11" (28cm × 28cm)
Courtesy of the Haines Gallery, San Francisco

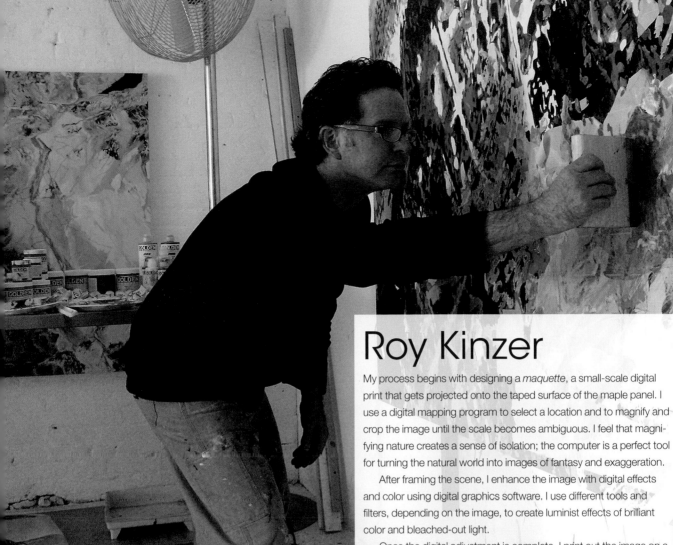

Roy Kinzer

My process begins with designing a *maquette*, a small-scale digital print that gets projected onto the taped surface of the maple panel. I use a digital mapping program to select a location and to magnify and crop the image until the scale becomes ambiguous. I feel that magnifying nature creates a sense of isolation; the computer is a perfect tool for turning the natural world into images of fantasy and exaggeration.

After framing the scene, I enhance the image with digital effects and color using digital graphics software. I use different tools and filters, depending on the image, to create luminist effects of brilliant color and bleached-out light.

Once the digital adjustment is complete, I print out the image on a color photo printer. This print is my maquette, which I refer to throughout the rest of the process, using traditional observation skills as well as nontraditional projection.

Artist Roy Kinzer at work in his studio

My paintings are aerial landscapes derived from altered topographical maps and digitally manipulated satellite images.

Kothen
Roy Kinzer
Acrylic and collage on wood panel
48" × 51" (122cm × 130cm)
Courtesy of the artist and Denise Bibro Fine Art, New York

W. C. Turner and the nineteenth-century luminist landscape painters are a major influence in my work. Turner achieved many of his luminist atmospheric effects during "Varnishing Day" at the Royal Academy of Arts in London. The tradition was for artists accepted into the annual summer exhibition to use that day (which was really closer to a week) to touch up their paintings just before the exhibition opened to the public. These artists usually applied picture varnish to their completed works, while Turner created light by rubbing Flake White oil into his paintings.

preparing the surface

I use cabinet-grade maple plywood supported by a wood frame glued to the back. Maple contains few natural oils and will change little over time. To me, it's worth it to feel confident and not have unhappy collectors.

I prime the maple with three layers of GAC 100 to provide protection from support induced discoloration (see page 19). I then add three coats of gesso tinted with fluid acrylics to provide adequate absorption.

applying the initial layers of paint

Here I'm using a squeegee to apply heavy body paint mixed with Acrylic Glazing Liquid over the initial tracing of masking tape. This step is repeated fifteen to twenty times for each painting.

building layers

As the painting progresses, I tape off smaller and smaller areas of detail to bring out elements that need more or less focus. Eventually I stop masking and start applying the paint more freely, using squeegees and sponges to apply thin layers of heavy body and fluid acrylics. I constantly refer to the digital maquette as I adjust each area of detail to make sure the colors remain true.

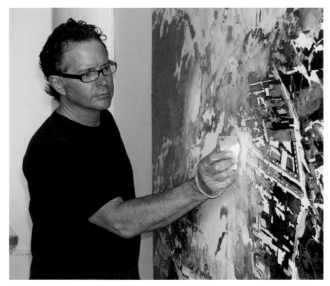

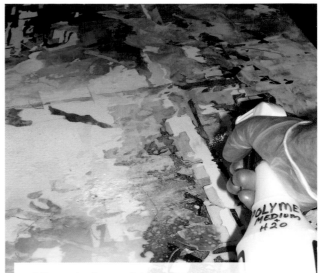

adding a luministic effect

I create a luminist effect by rubbing Zinc White mixed with Acrylic Glazing Liquid with a sponge to blur certain areas of the image. In areas where I want the brightest bleached-out whites, I use Titanium White mixed with Acrylic Glazing Liquid.

adding cutout map details

I find cutting out highways from a road atlas to be obsessive play. As I cut, I follow a road that leads to another road, and another and another, and the next thing I know a journey has been mapped out. Once the highways are removed from the atlas, they become a filigree of colorful paper lines. I usually do this cutting at the same time that I'm rubbing the luministic atmosphere into the painting. I cut, look, rub, and cut again. The roads dance down and flatten themselves out when sprayed with a mixture of 1 part water to 1 part Polymer Medium.

applying a special recipe isolation coat

Here I use a mixture of Self Leveling Clear Gel, GAC 500 and water to build, level and flatten the surface. I apply 5–6 thin layers of this mixture, applying one every day until the surface is flat. This is really a very thick isolation layer to protect the painting. I wait three more weeks before applying the MSA Varnish.

Contributing Artists

Tesia Blackburn

www.blackburnfineart.com

All You Need Is Love, page 124

©Tesia Blackburn

Patti Brady

www.pattibrady.com

Fruitless Fruitlla, page 2

On a Silver Platter, page 5

Loop de Loop, page 7

Tripod, page 8

Seersucker Geraniums, page 11

Peachy Keen, pages 21 and 32

Toad Lily (Detail), page 27

Florabunda Obatta, pages 87 and 96

Primula/Primel, page 90

Eve's Weed Midnight, page 105

Eve's Weed, page 105

Pink Flesh and Fish Nets, page 117

©Patti Brady

Dianne Bugash

www.diannebugasharts.com

Lady in Green, pages 135 and 144

Womansphere, page 140

Earthbound: Elephant Walk, page 142

©Dianne Bugash

Jaq Chartier

www.jaqbox.com

6 Lanes, page 152

©Jaq Chartier

Bonnie Cutts

www.bonniecutts.com

Floating Upward, page 39

Buds Appear, page 49

Untitled, page 68

©Bonnie Cutts

Barbara De Pirro

www.depirro.com

Circular Chaos, pages 99 and 107

©Barbara De Pirro

Mathieu Emmanuel

www.mathieu-emmanuel.com

Par Dessus l'Épaule, page 111

©Mathieu Emmanuel

Frances Ferdinands

www.francesferdinands.com

Seduction, page 143

©Frances Ferdinands

Phillip Garrett

www.philgarrett.com

Self Portrait, pages 65 and 71

Mando Dog and the Heeler Sisters, page 70

Day Lilies Strata, page 91

Memento/Lake at Ryoanji II, page 138

Falls on the Reedy II, page 143

©Phillip Garrett

Declan Halpin

http://declanhalpin.com

Viral, page 152

©Declan Halpin

Barbara Jackson

WWW.barbarajacksonartist.com

Night Trains Passing, page 126

©Barbara Jackson

Ulysses Jackson

www.ulyssesjackson.com

Water Garden, pages 53 and 61

©Ulysses Jackson

157

Index

Liberate your artistic vision with
North Light Books

Acrylic Revolution will show you everything you need to know to be successful in your acrylic painting projects. With over 101 of the most popular, interesting and indispensable tricks for working with acrylic, there is literally page after page of acrylic instruction and inspiration for everyone from artists, to crafters, to weekend enthusiasts, to students of all levels. A gallery of finished art at the back of the book will show readers how to combine different tricks to use in your artwork offering you real-life applications for acrylic techniques.

ISBN: 978-1-58180-804-9, ISBN-10: 1-58180-804-6, hardcover with spiral binding, 128 pages, #33483

Get up and make some art! *Kaleidoscope* delivers your creative muse directly to your workspace. Featuring interactive and energizing creativity prompts ranging from inspiring stories to personality tests, doodle exercises, paper dolls and cut-and-fold boxes—this is one-stop shopping for getting your creative juices flowing. The book showcases eye candy artwork and projects with instruction from some of the hottest collage, mixed media and altered artists on the Zine scene today.

ISBN-13: 978-1-58180-879-7, ISBN-10: 1-58180-879-8, paperback, 144 pages, #Z0346

This book will lead you on your quest to find your own unique artistic style. Touches on virtually every aspect of "voice," based upon the perspectives of 30 different artists working in a variety of mediums. Every page will take you one step closer to discovering what you want to say in your art, and how you want to express it.

ISBN-13: 978-1-58180-807-0, ISBN-10: 1-58180-807-0, hardcover with spiral binding, 176 pages, #33486

These and other fine North Light books are available at your local art & craft retailer, bookstore or online supplier or visit our website at **www.artistsnetwork.com**.